CHARLIE ADLARD
DRAWINGS + SKETCHES

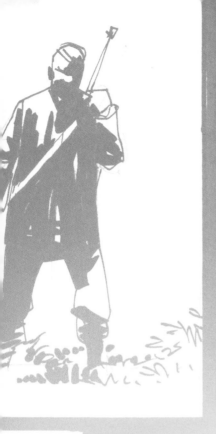

Drawn and written by: Charlie Adlard

Edited by: Tim Pilcher

Design by: Sha Nazir

Photography by: Tim Pilcher

Based on publication design by: Kirsty Hunter
Drawings + Sketches format created by Sha Nazir

First printing 2021

Published in Glasgow by BHP Comics Ltd

ISBN: 9781910775264 (Softback edition)
ISBN: 9781910775271 (Hardback edition)

Made in Scotland. Printed in Great Britain by Bell & Bain Ltd, Glasgow

A CIP catalogue reference for this book is available from the British Library

Ask your local comic or bookshop to stock BHP Comics. Visit **BHPcomics.com** for more info.

CONTENTS

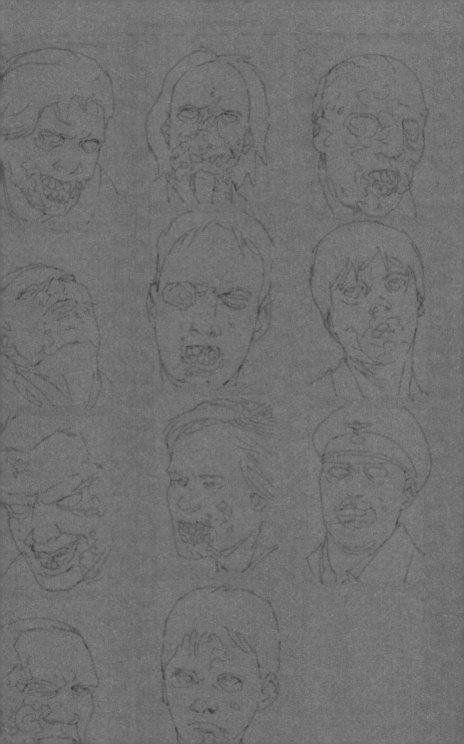

THE WALKING DEAD

(AND OTHER ZOMBIES)

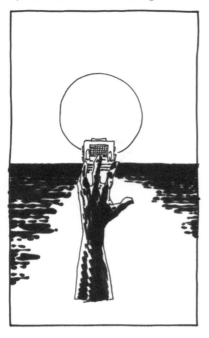

This page and next: Survival of the Dead poster (2010)
"I did a special edition film poster for George A. Romero's last film. Unfortunately the film was fucking awful."

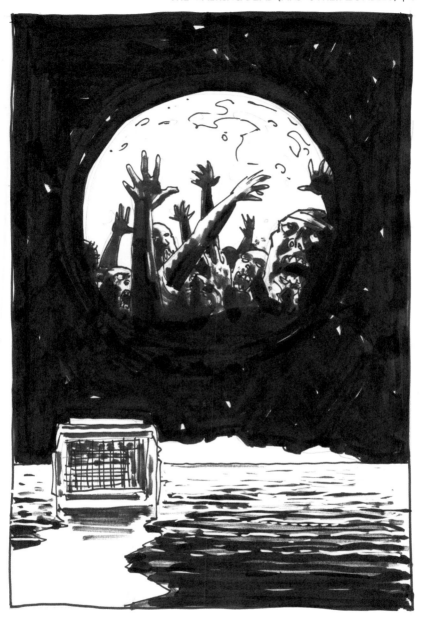

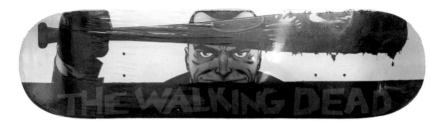

Above and Right: Skateboards
These hardwood custom skate decks based on a cover variant featured Charlie Adlard's **Walking Dead** artwork, including fan favorite character Negan, with his baseball bat 'Lucille'. Each were limited editions of 200.

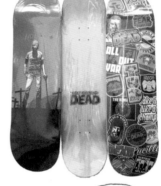

Below and Opposite page: Zombie Plushie Design.
"This is the only time I've been asked to provide model sheets. Not sure if they ever produced them in the end."

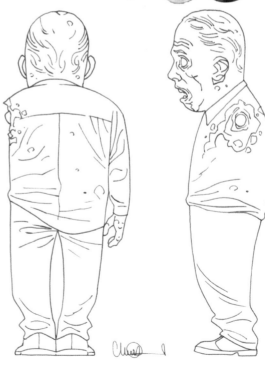

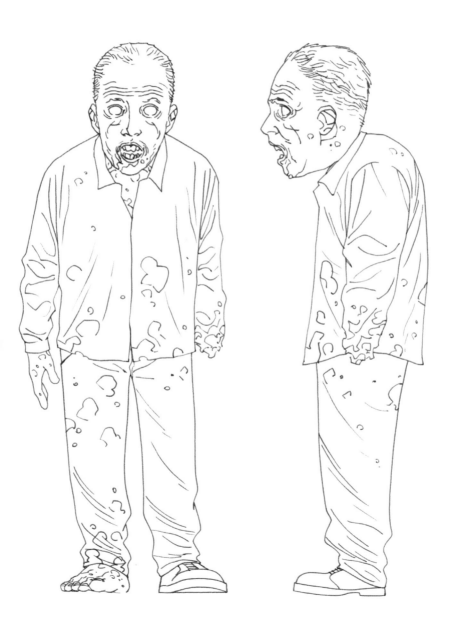

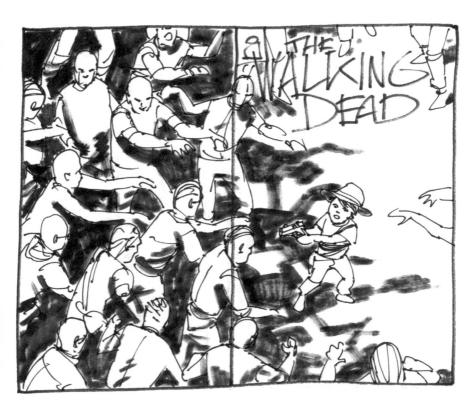

Above: Wraparound cover rough for **The Walking Dead** #50

"You don't work with someone for 15 years without a few arguments, but nothing serious! Our first disagreement was over the variant cover for #50. My idea was to do an Edward Hopper homage of a house, woods and a lot of sky, and this ominous feel to it. No characters at all. Image Publisher Eric Stephenson and Robert [Kirkman] wanted a big close-up of Rick being threatened by a shadow of potentially a zombie. I didn't want to do that as it was really boring. Eric sent me an email saying, 'We can't have a cover with just a house on!' And I replied, 'Do you think they said to Dave Gibbons with **Watchmen** "You can't just have a badge on the cover!"'? [Laughs] So I lost that argument and I drew it in the end! We only had 5-6 arguments in 15 years! Ultimately the cover works really well."

Opposite page: Unused cover thumbnail
"By the time I'd got up to issue 100-and-whatever it got very hard not to start repeating myself on cover designs. It's hard when you're limited by the same shape every month and it's easy to end up relying on a lot of 'clichés' for want of a better word. Because there's only a certain amount of set-ups you can do. So when a potentially original design pops into my head it's always exciting! So I'm always trying to do something different. The problem with an ongoing series is that only the writer knows what's coming up. Robert knew what was going to happen three month's in advance. But I didn't have a script to work from so I could only go on Robert's suggestions. And I'd have no other choice but to draw that, as I had no idea what else was happening in that issue. Which could be a bit frustrating at times. Very rarely he'd send 10 thumbnails for covers, but normally it was just a description. Eight out of 10 times I'd just tweak it to improve the design. And the other two times I'd just explain that the idea wasn't going to work and then we'd thrash it out together. Or the third option was a radically different design by me!"

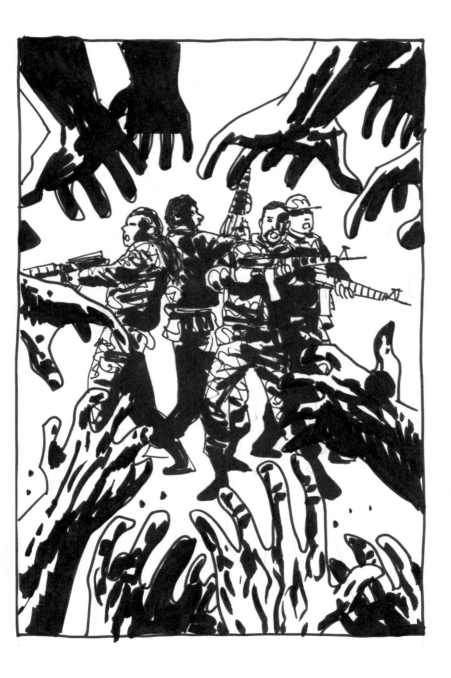

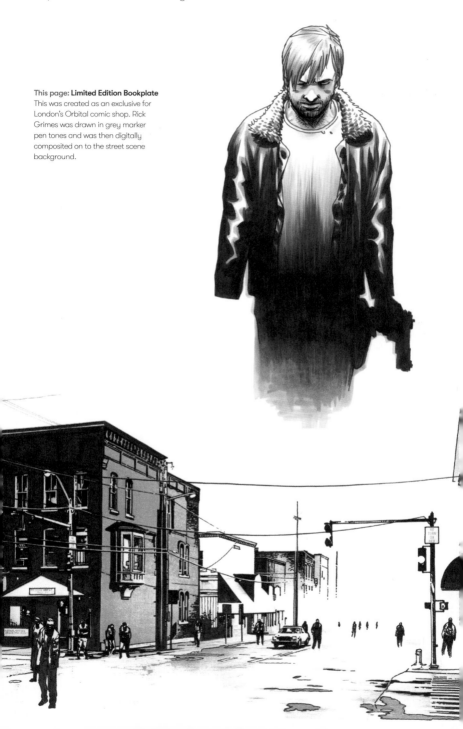

This page: Limited Edition Bookplate
This was created as an exclusive for London's Orbital comic shop. Rick Grimes was drawn in grey marker pen tones and was then digitally composited on to the street scene background.

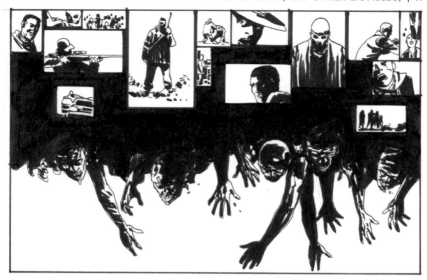

Above: Unpublished promo layout art for Telltale's first **Walking Dead** video game.

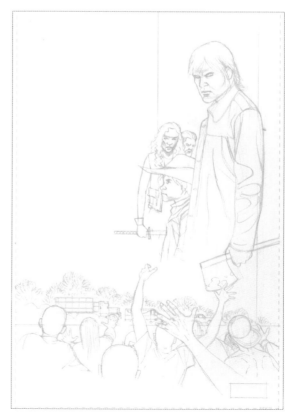

Right: Pencils for a limited edition print created especially for the Bristol Comic Expo.

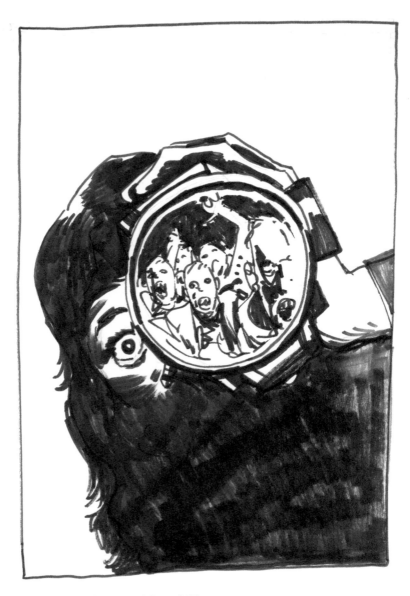

Above: Diary of the Dead Special edition DVD cover (2008)
concept
Opposite: Finished Art

"**The Walking Dead** has opened more doors than it's
closed, to do projects like this, which I'm eternally grateful

for. But at the risk of sounding ungreatful...as soon as I
finished the last issue of **TWD** I was approached by Marvel
and DC to do covers for **Marvel Zombies** and **DCeased**! So
the thought process is automatically linking me to zombies.
I naturally turned them both down. 15 years is a long time
for anyone to be drawing zombies."

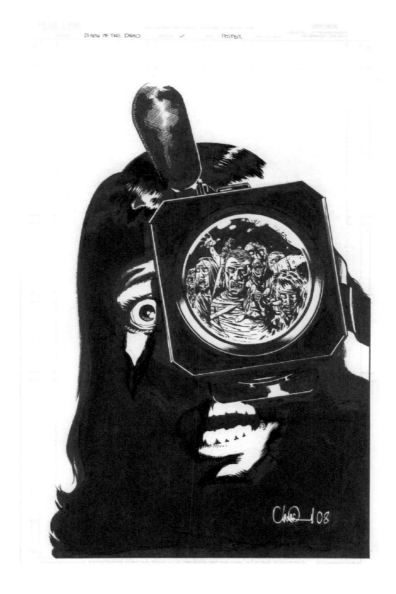

"*The Walking Dead* has opened more doors than it's closed, to do projects like this, which I'm eternally grateful for.

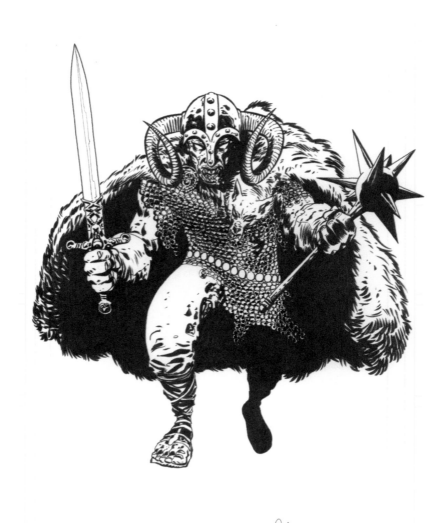

Above: Zombie Viking (commission, 2009)

"When you're drawing something like **The Walking Dead** with a potential readership of hundreds of thousands I have the attitude that you can't please all the people all the time, so why bother? I'll just draw it for myself. If 50% like what I've done, brilliant! That's a lot of people! But doing a commission for one person, you've got to please them. So, ironically, I find commissions more pressured than doing a comic for a massive audience."

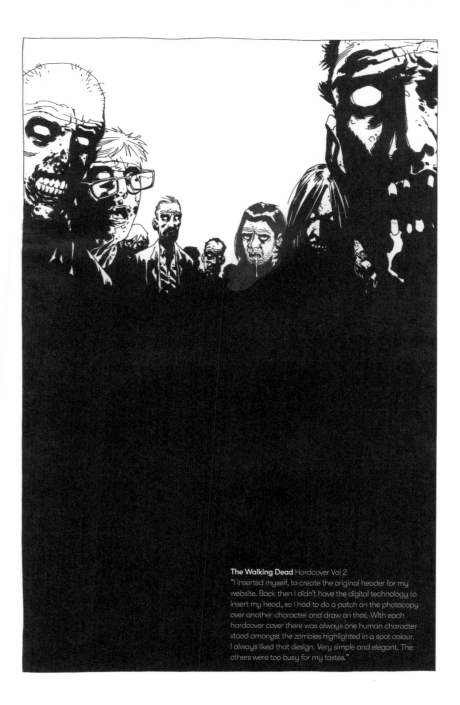

The Walking Dead Hardcover Vol 2

"I inserted myself, to create the original header for my website. Back then I didn't have the digital technology to insert my head, so I had to do a patch on the photocopy over another character and draw on that. With each hardcover cover there was always one human character stood amongst the zombies highlighted in a spot colour. I always liked that design. Very simple and elegant. The others were too busy for my tastes."

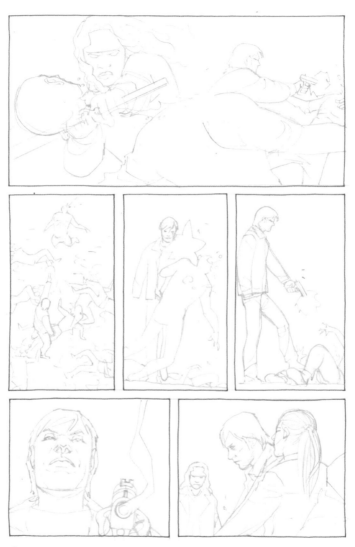

The Walking Dead #106, Page 11 (Writer Robert Kirkman, Image Comics, Skybound LLC, 2013)

Above: Finished pencils

Opposite page: Finished inks

"Generally speaking there's about five panels on a page and three rows. Probably the most common layout is three small panels, one wide panel, and two medium panels. Obviously that's interchangeable. It wasn't intentional, it just worked out like that. I've always been a fan of simple storytelling. It's the difference between conceptual art which is say, just a pile of bricks, and say a representative painting. With the later you can just appreciate it for

WALKING DEAD 106 11

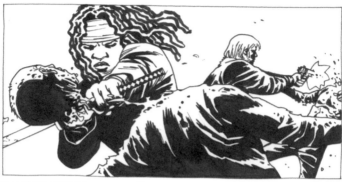

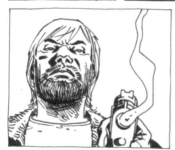
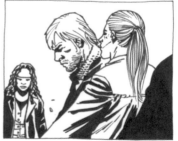

what it is rather than the history behind it. So some artists like to do crazy page layouts as opposed to me, who lays it out simply, because at the end of the day that's more accessible to the general public. You want them to concentrate on the drawing in the panels and how good is the storytelling, not how amazing this artist has laid out the page, which can bring you out of the story. You look at some artists who just do stupid page layouts and you just go 'Why?' it's such a bad design or a crazy shaped panel and it doesn't make sense why the panel is that shape. So long as you can read the page from left to right, top to bottom, then most newbies can access comics. **The Walking Dead** was 15 years of my life and will probably be the thing I'll be most remembered for."

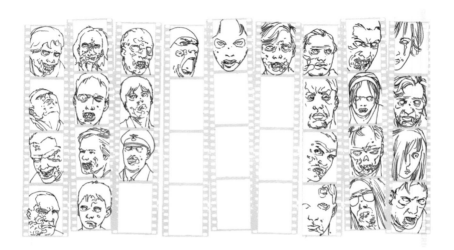

Doc of the Dead (2014)

"This was a documentary about zombies. made by Alexandre O. Philippe (who directed **The People Vs. George Lucas**). He approached me because of my work on **The Walking Dead** and I was interested in designing another film poster."

Top: Logo Design pen and ink

Above: Poster background illustration pen & ink

Right: Finished poster design

Opposite page: Main image illustration, that was done using Pentel Colour Brush pens, and whiteout for the teeth

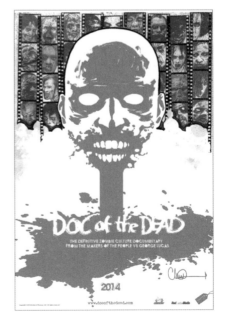

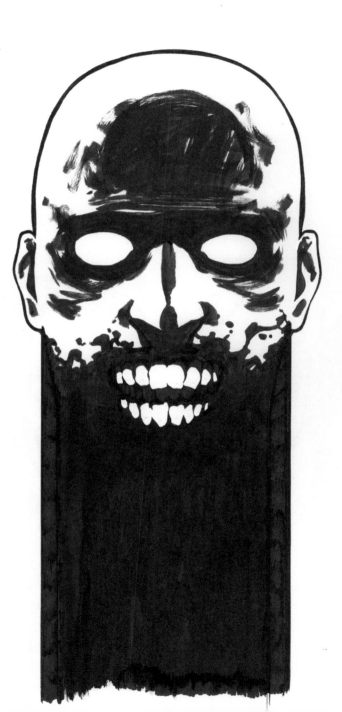

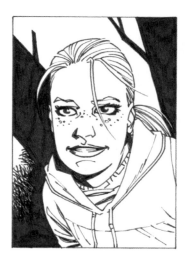

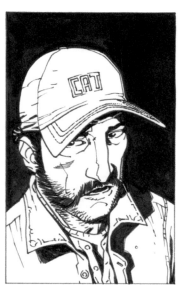

"At one point I was asked to draw my versions of the characters before I'd joined *The Walking Dead.* including (clockwise from top left): Morgan, Duane, Jim, and Andrea's sister, Amy. The idea was 'What would your versions be like if you'd drawn them?'"

"This was a design for some zombie signing plates for a *TWD* Skybound special edition. It does look like Iggy Pop! I can't remember if I was inspired by him." This predates Iggy playing a zombie in Jim Jarmusch's *The Dead Don't Die* by 12 years!

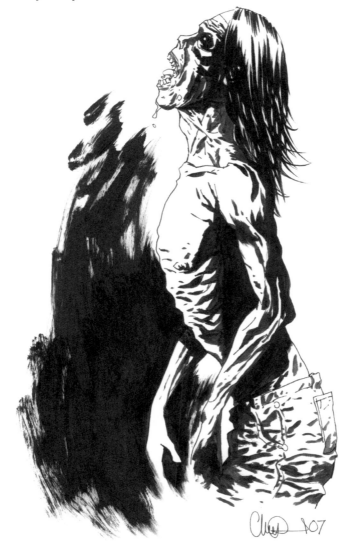

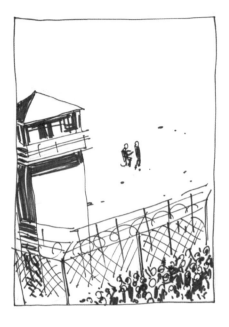

Left top:
Thumbnail sketch for the cover to **The Walking Dead** #36.

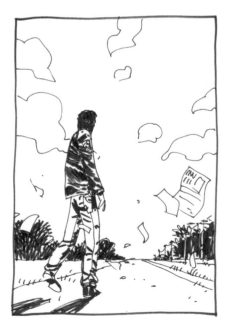

Left bottom:
Thumbnail sketch for the cover variant to **The Walking Dead** #75.

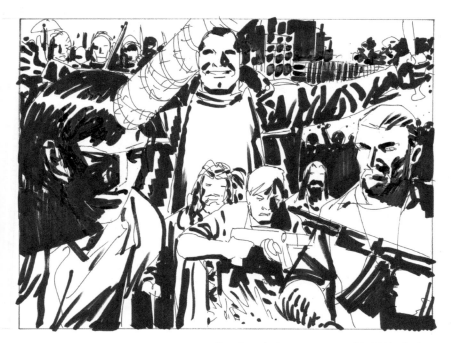

Above: Sketch for the wraparound cover of **The Walking Dead** Omnibus Vol. 5

"I used to always do a rough as Robert wanted me to put in any significant moments from that part of the story, so they were always a filmic montage"

Below: Unused Banner Design Sketch (2010)

"This was an initial design for what eventually was used at San Diego Comic Con to launch **The Walking Dead** TV series. Robert asked me to draw the comic characters on one side, reflecting the TV actors on the other."

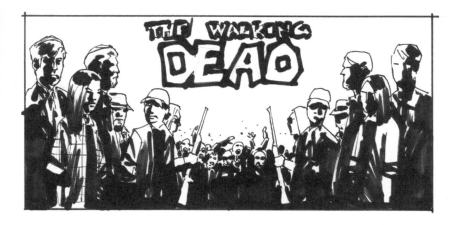

VAMPIRE STATE BUILDING

"The concept was great and the title is brilliant and I loved the synopsis by Ange and Patrick Renault. I'd already done **Breath of the Wendigo** for Soliel, and Delcourt—by this time—had bought Soleil, who were my French **Walking Dead** publishers. My editor, Jean Wacquet, approached me with the title and I thought 'I can't believe that hadn't been taken before. It's too good, yet too obvious.' It took me years to finally say yes because I was so busy with **The Walking Dead**. And they kept saying 'We'll wait, we'll wait!' and so they just wore me down! [laughs], but I took nearly two and a half years from Soleil initially asking me, before I could start **Vampire State Building**, because of **TWD** business."

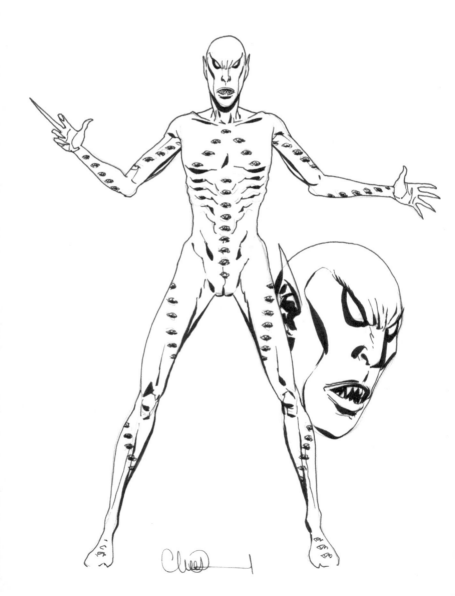

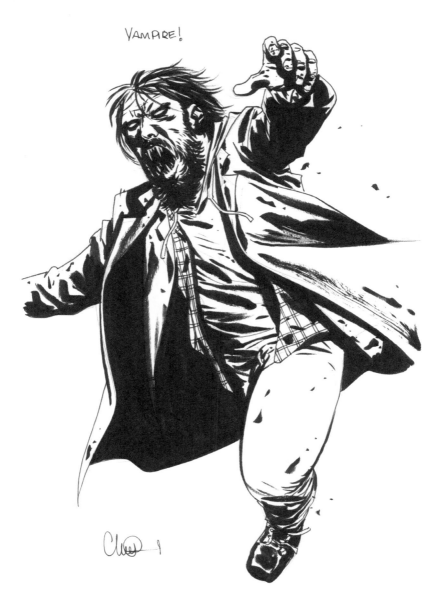

VAMPIRE!

Above: Vampire State Building, quick character sketch.
Vampire, pen and ink

Opposite page: Vampire State Building, quick character sketch.
The bloodsucking God, U'tluntla, pen and ink.

Vampire State Building #3 cover
(writers Ange & Patrick Renault,
Ablaze, 2014)

"This vampire face was inserted into
my original cover, which ended up
not on the French edition but on some
promotional material and one of the
US variant covers."

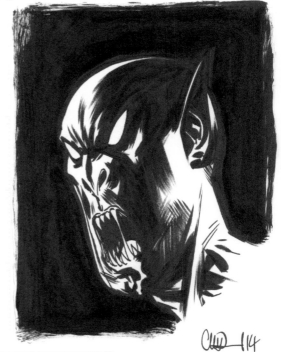

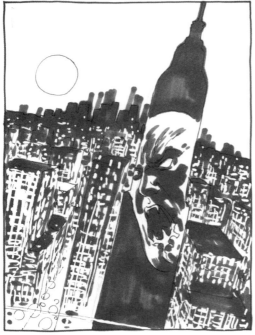

Opposite page:

"This was a blueline made from a
photograph of New York City and
you can see other angle of NYC in the
background. When inking a blueline
I'll ramp up the contrast and make
those decisions on what will be black
or white. If I'd had a photograph at
the side as a refernce I'd probably
end up with a very similar image, but
it'd just take three times longer. I can
do perspective in my sleep, but it just
takes a lot longer."

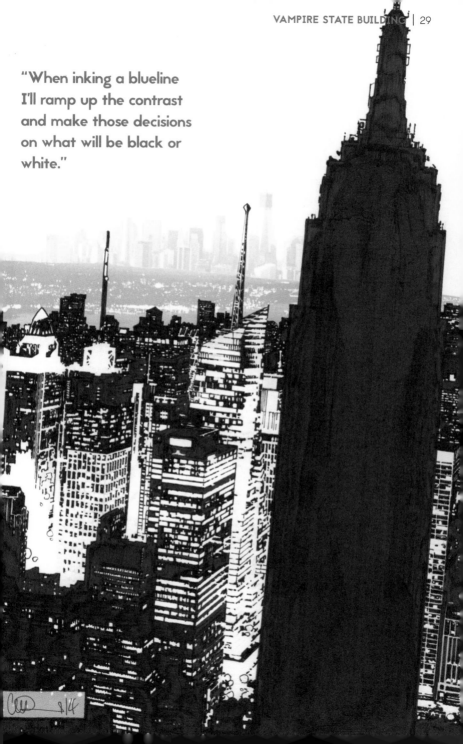

"When inking a blueline I'll ramp up the contrast and make those decisions on what will be black or white."

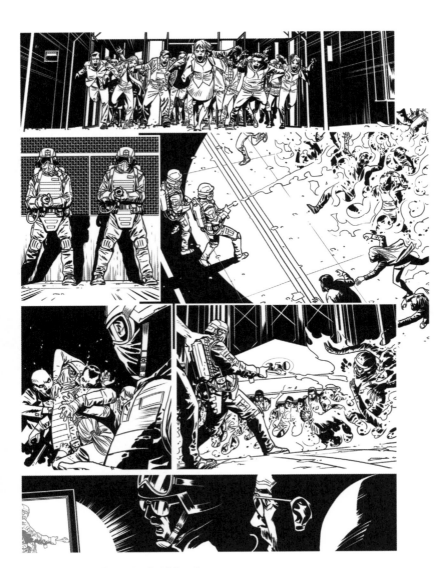

Vampire State Building, Finished Inks, Book 2, Page 16
"Unless there's something specific, I generally prefer to keep a bit of a 'hands off' approach with colourists, as being a creative myself, I wouldn't like to be told what to do all the time."

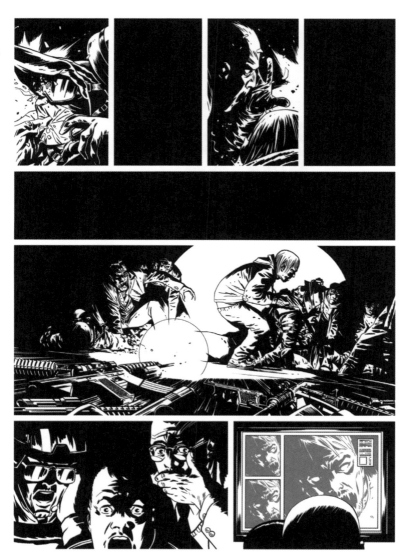

Vampire State Building, Finished Inks, Book 2, Page 34
"The best colourist I've worked with has been Dave McCaig,
who's currently colouring **The Walking Dead**. He's been
doing it for the past four years and he's up to #100!"

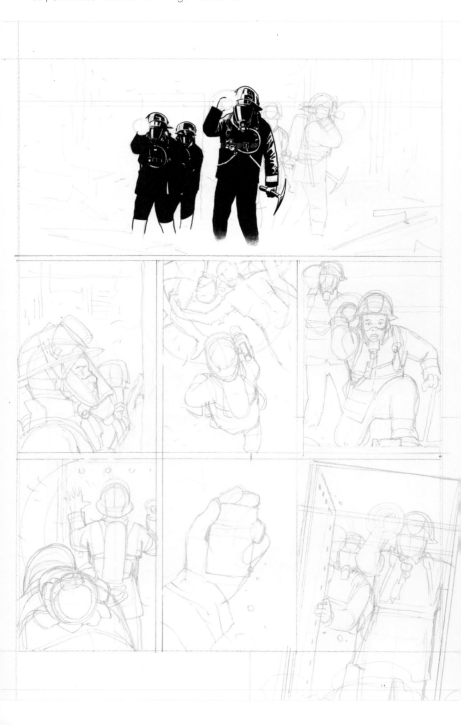

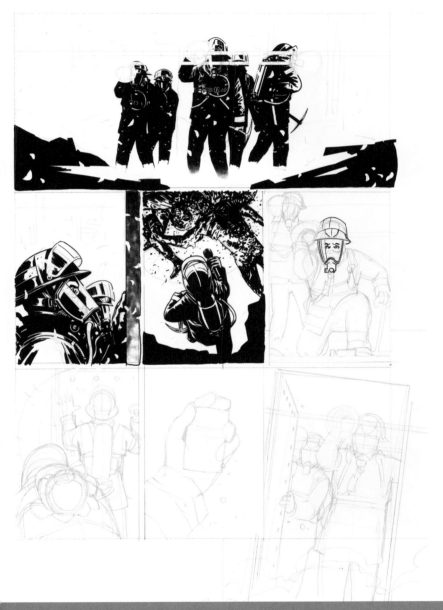

"I don't have particular layouts that I use all the time, as I'd find that too restrictive, but sometimes I'll use a certain system of laying out panels. With **Vampire State Building** I did a lot of inset panels, as I thought it was an action-thriller, so you'd have big scenes that fully bleed, so it's nice to break them up.

I'm actually a fan of panel borders, I'm not a big fan of full-bleed, because you have to work out how it relates to the opposite page and can be confusing if you've got two full bleed panels on opposite sides, which can be confusing to a newbie reader, as they come together in the middle. It just looks too busy and cluttered!"

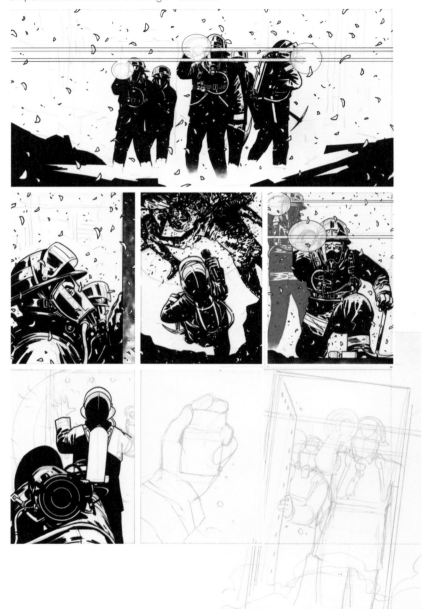

Vampire State Building
"The blueline pencils were just drawn physically on one page and then scanned in and digitally inked. The beauty of digital is that I'd never be able to get such good smoke effects or creating the ash and litter would be a real pain. That was added later.

This was the first book I inked completely digitally. To be honest pencilling on a cintiq or on paper is much of a muchness."

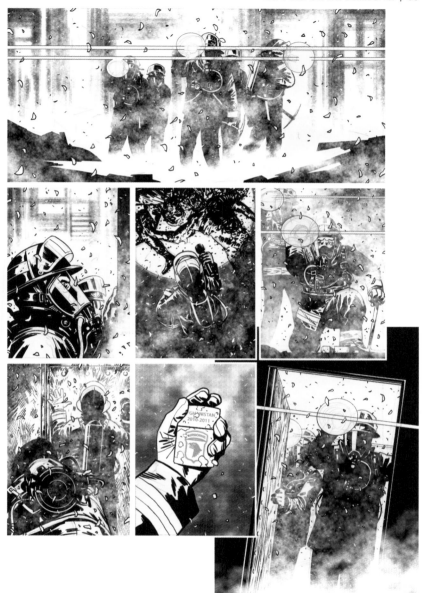

"I later laid down the panels and grid structure digitally and tidied up the panel borders in white. I'm wary of working with lots of panels on different layers, for me that is just too many layers, because it's confusing and my poor, little brain can't cope with loads and loads of layers! I'd just end up drawing on the wrong layer and then chaos just ensues! But I did all the effects on a separate layer for the colourist (in this case Sébastien Gérard) otherwise they'd hate you forever! Obviously when I send it to the publisher I remove the blueline layer."

TERRY FISHER

"At the end of the day I'm never going to draw the same face twice, but I do rely on stock images. Characters may have different features or hairstyles, but I tend to draw from a stock set of charcter designs locked in my head. And I use loads of tricks to make them appear different. But to make every face I draw exactly photorealistic and different would take forever, and in comics you don't have forever. That's why I call myself a cartoonist, because we all caricaturise things, and the more heavily we do that more the recognisable each individual face is. I don't heavily caricaturise too much, so I set up my own series of problems as well. But it's still primarily about caricature, and still looking for those defining features and integrating them into your own character's faces."

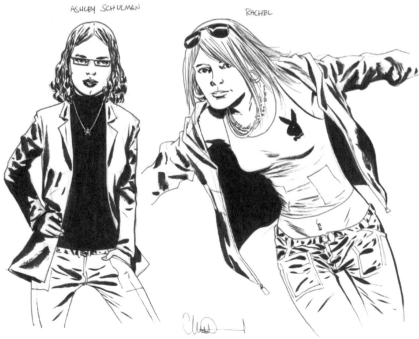

ASHLEY SCHULMAN

RACHEL

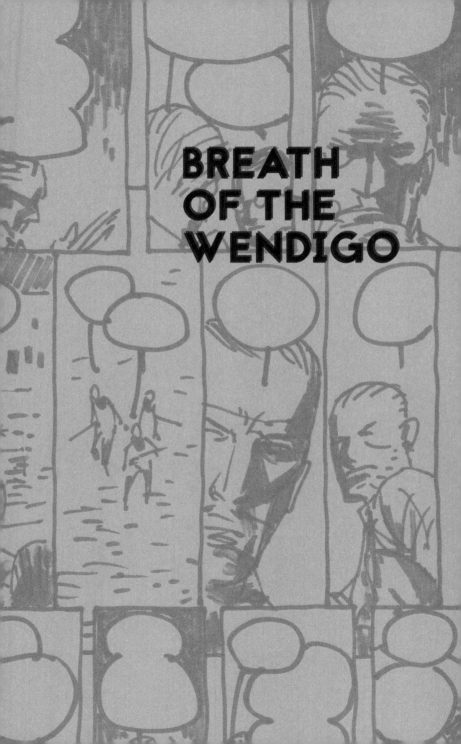

BREATH
OF THE
WENDIGO

Below: Character sketch marker pen

Opposite page: Character headshots, pencil.

Written by Mathieu Missoffe, **Breath of the Wendigo** is set in World War One and features Cree Native American Wohati as he battles a supernatural force that threatens both the French and German trenches.

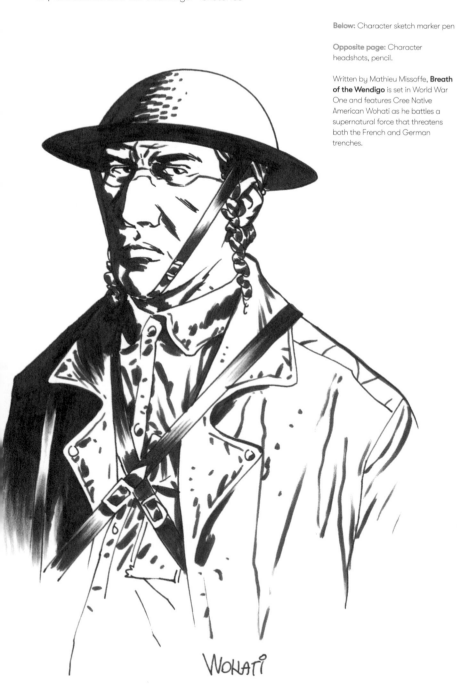

WOHATI

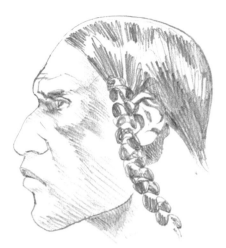

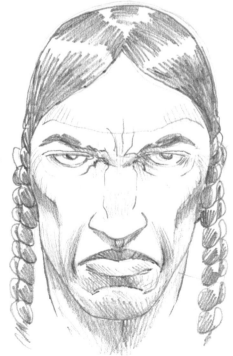

WONATI (PENCIL STUDIES)

LUBIN

This page and opposite: Ink studies of Lubin
"The story is a 'men on a mission' tale, and so there are lots of
characters who slowly get killed off and Lubin is one of them!"

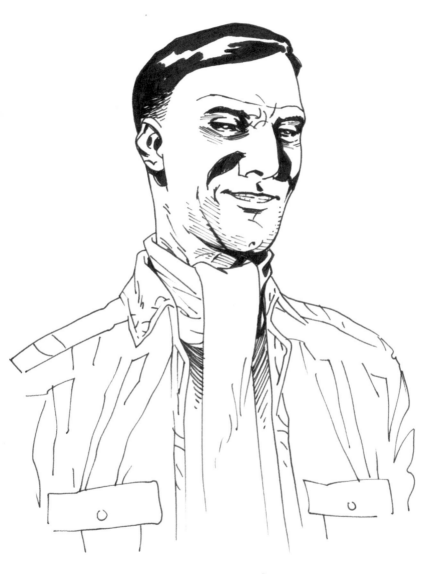

LUBIN (II)

Originally published by Soleil/Delcourt in 2009 in French under the title **"Souffle du Wendigo (Breath of the Wendigo)"**, the series was then published in English by Dynamite in 2012 under the title, **The Curse of the Wendigo**.

Opposite page:
Watercolour cover for the
French reprint edition (2011).

Right: Charlie's watercolour was reused for the collected edition of the English language digital comic on Comixology.

Below: Ink character sketch
"In the book there's a half-French/half-German team that go after this Wedigo, and Berger and Wolf are from the German side."

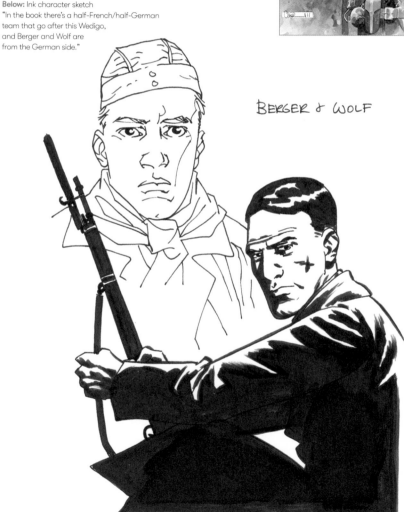

BERGER & WOLF

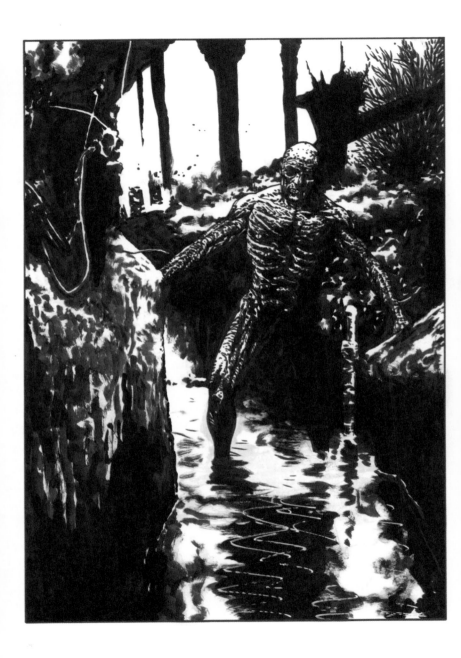

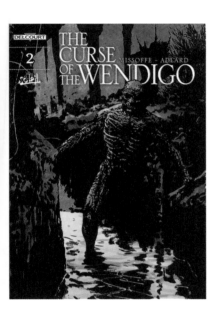

The Curse of the Wendigo #2 cover
"This was never intended to be a cover. It was a bit of an experiment and the first time I'd ever tried printing out a blueline background and inked over it."

Opposite page: Ink and brush pen over blueline.

Left: Final cover, colours by Aurore Folny. Reused for the second issue of the English language digital comic on Comixology.

Below: Character sketches
Lucius and Clovis are two French soilders.

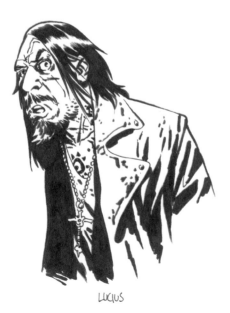

LUCIUS

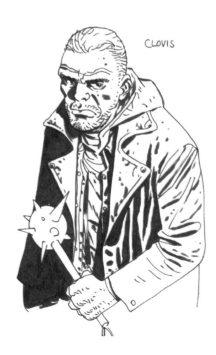

CLOVIS

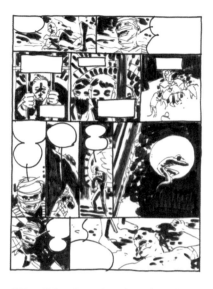
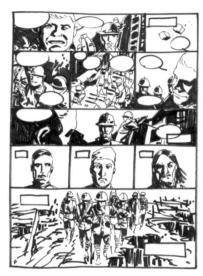

"On *Wendigo* the thumbnails were all done in cheap felt-tips and marker pens, which I'd never use on finished artwork."

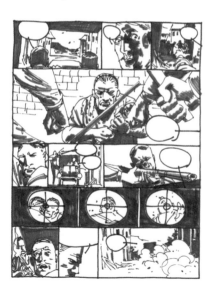
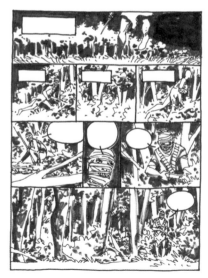

Above, opposite and following: Thumbnails ink marker

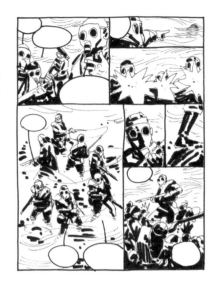

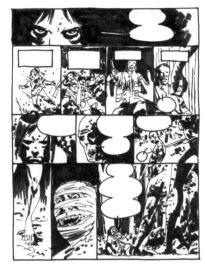

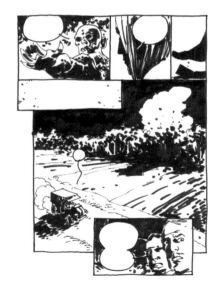

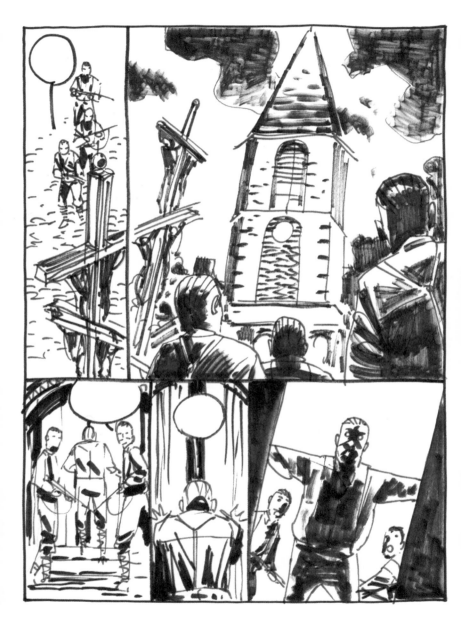

"The only reason I drew the balloons on to the thumbnails is because I wanted to hand draw the balloons onto the artwork—because I like the shape and look of them—which was a very bad idea on my part! Because I had to write in the French text on the artwork so I could size the balloons correctly and I couldn't think of any other way of doing it. It was way too time-consuming!

Some people say that you save time by not drawing the art that's going to be hidden by balloons anyway, but I found the whole process just slowed me down."

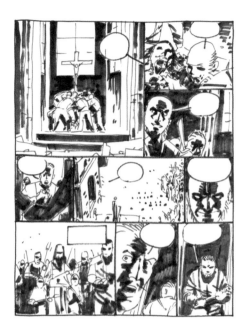

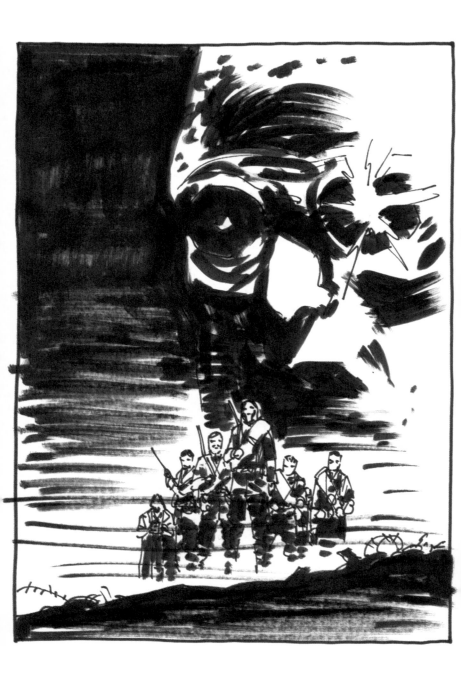

Opposite page:
Cover rough for the first French
edition (Dargaud/Soleil, 2009).

This page:
Character sketch of the titular
antagonist.

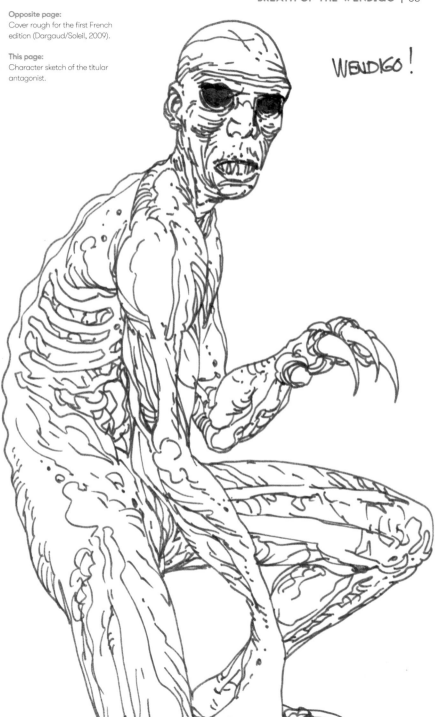

WENDIGO !

Right:
Blueline reference photo of trenches.

Below: The cover to the first issue of
English language digital comic on
Comixology.

Opposite page:
Cover inks over blueline for the French
edition.

"Again, this was an experiment. I
never intended this to be used as a
cover. I'm happy with the images, so
that's fine that they were used this
way." You can see the original photo
was of British Tommies, which Charlie
then converted to French soldiers,
"You get the original image and just
manipulate it to your own means.
But if you want to get as realistic
as possible you can't beat using an
actual photograph!"

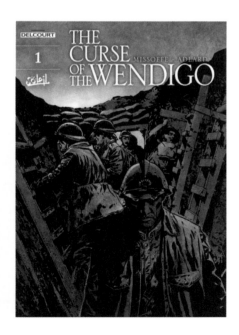

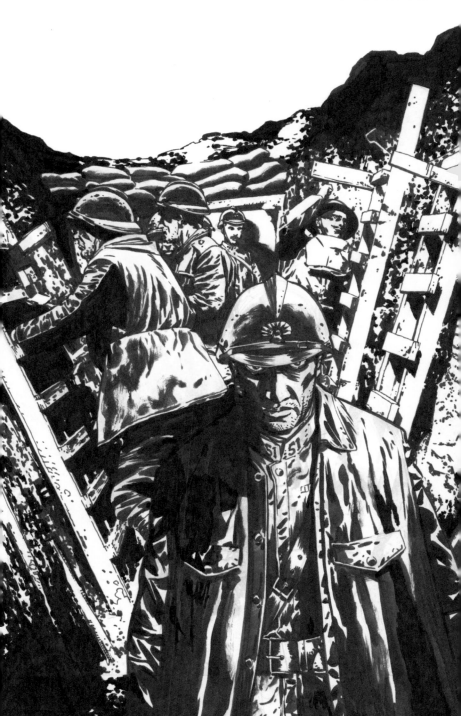

"I thumbnailed this in such detail because most pages had 7-9 panels, which is a lot, and it wasn't in a grid, so every page layout was different, so I needed to step back and see it thumbnailed. And I was doing the balloon placements at the same time. The ballooning did effect my composition because I was conscious of how much space was needed for each balloon. I'd make a panel larger if it had more text in it. It can often be disingenuous on other books to think 'Ah, the letterer can sort this out!' So this enlightened me to the problems letterers might have working on other books."

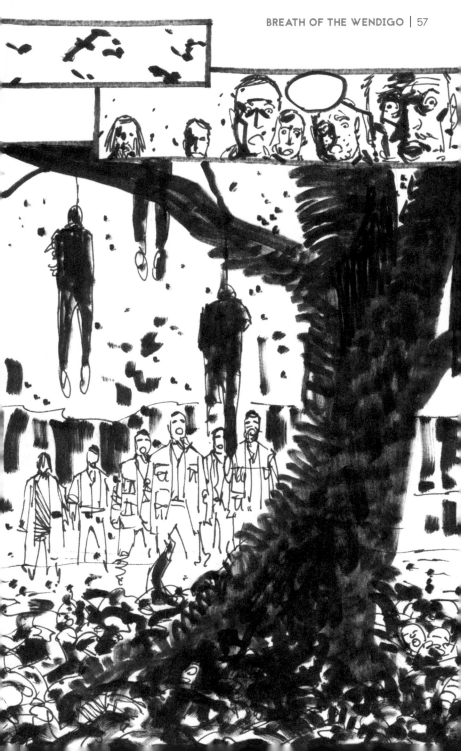

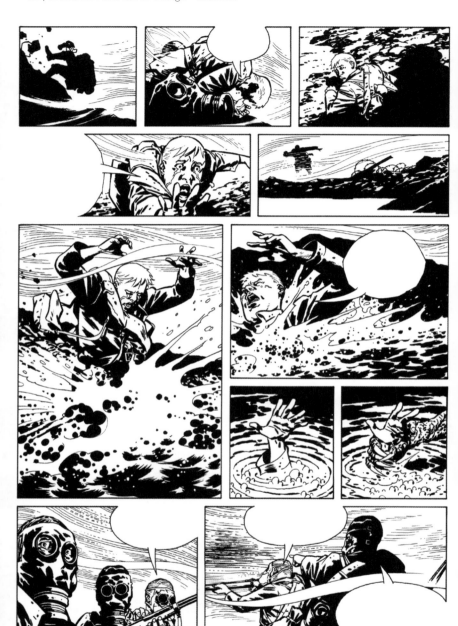

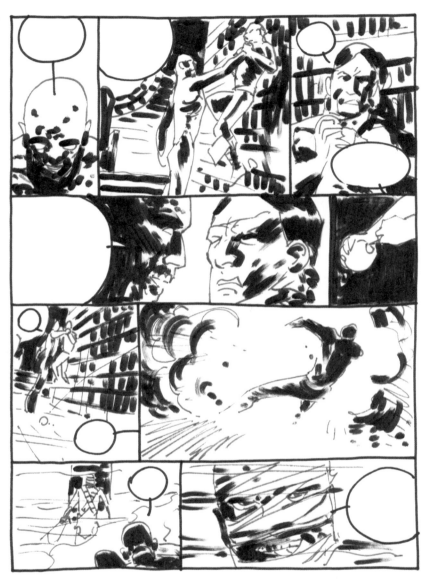

Opposite page: Finished inks of Page 22.

Above: Thumbnail
"With big speech balloon on the left hand side of the fourth panel, I wonder if I hadn't put that balloon in there myself would I have done that composition? With the head so far over when talking to the other guy. With the benefit of hindsight, walking away for a bit and coming back, I started pencilling it out and realised I could do it better than the thumbnail and redesigned the panel."

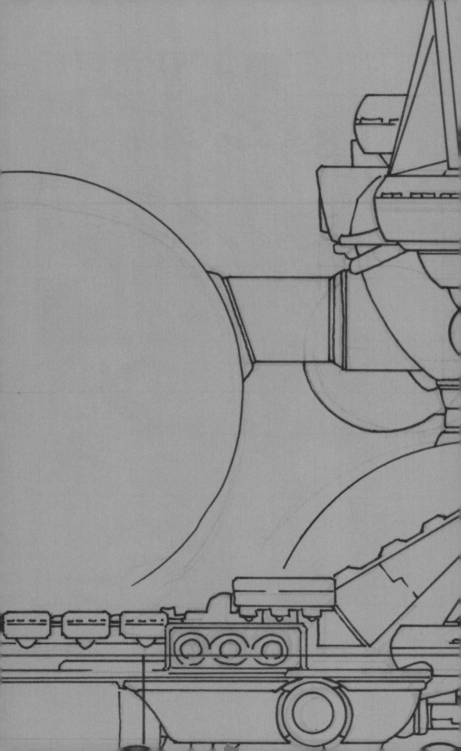

PASSENGER

"*Passenger* was conceived as a one-off story. I suggested the format of a single BD album (a large, oversized hardback). Whether that was best format I don't know.

Robert Kirkman still talks about finishing it one day, so there's life in the old dog yet! Out of everything I've done *Passenger* is the most 'design heavy.' Because it's set on a spaceship everything had to be designed from the ground-up. Looking back on it now I'm surprised at how much I did."

Below and opposite: Initial character concpets, ink marker.

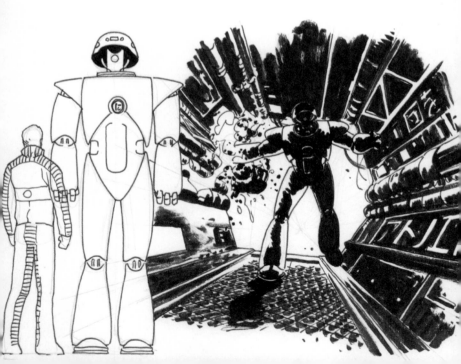

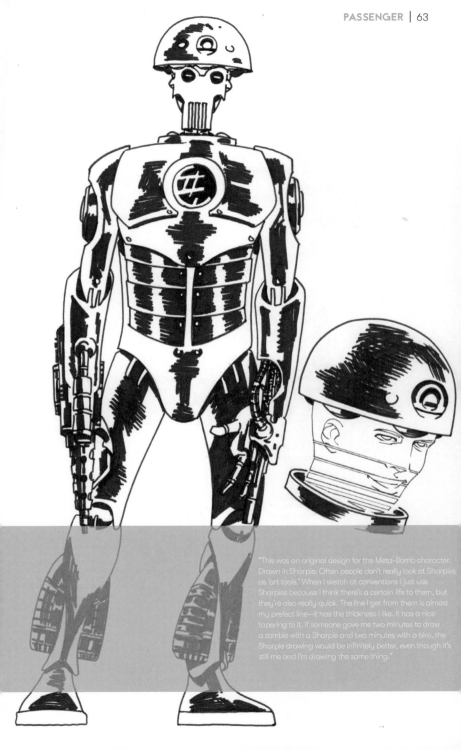

"This was an original design for the Meta-Bomb character. Drawn in Sharpie. Often people don't really look at Sharpies as 'art tools.' When I sketch at conventions I just use Sharpies because I think there's a certain life to them, but they're also really quick. The line I get from them is almost my prefect line—it has the thickness I like. It has a nice tapering to it. If someone gave me two minutes to draw a zombie with a Sharpie and two minutes with a biro, the Sharpie drawing would be infinitely better, even though it's still me and I'm drawing the same thing."

PENCILLER
TITLE
INKER
ISSUE #
PAPER
MONTH
INTERIORS

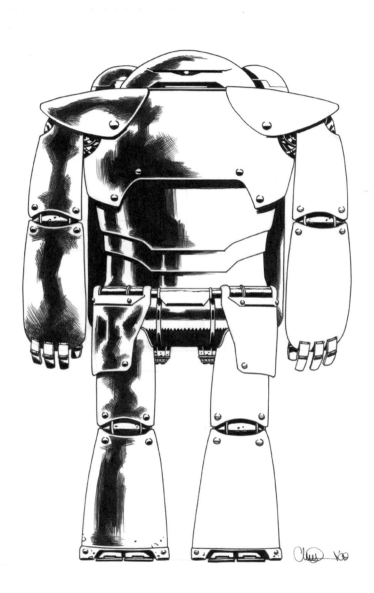

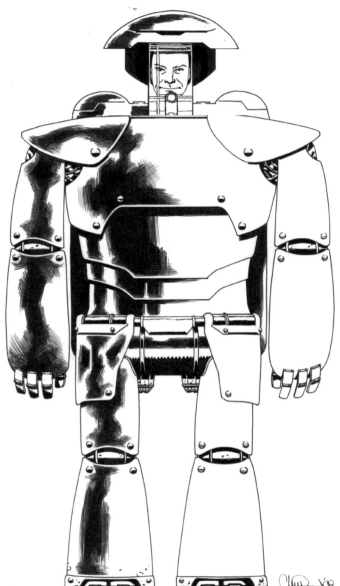

Meta-Bomb

"The idea was humanise these droids.
The company that made them would
have a projected head to make it look
less scary to the general public.
I preferred this design. I know it looks a
bit like Juggernaut from **The X-Men**."

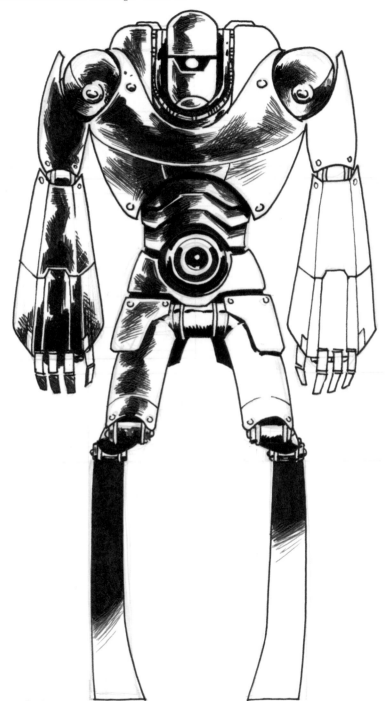

Meta-Bomb

The final, more dynamic redesign of the robot, this time with running blades added.

"There are 43 pages of original *Passenger* artwork drawn, it's nearly finished. Robert keeps promising he's going to finish it! I would have loved to finish it before starting *Heretic* with Robbie Morrison. I was going back over the pages and thinking 'this is really good!' I surprised myself!"

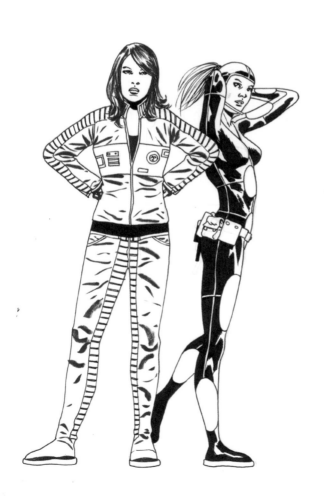

Left: Character designs
"These are secondary characters. Regarding costume design in spac̶ one of the biggest influences rem̶ **Alien,** in terms of functional clothi̶ The girl on the right is a navigator and so her costume interfaces wit̶ the ship via movement and acts a̶ part of the machinery, which was̶ my idea."

Opposite page: Thumbnail of the final cover design featuring Meta-Bomb. "I like the use of negative space. The original cover I drew w̶ a much more classic film poster st̶ but it felt too cliched."

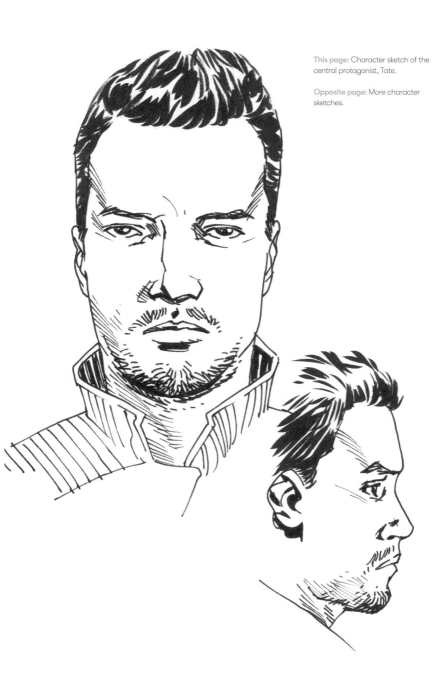

This page: Character sketch of the central protagonist, Tate.

Opposite page: More character sketches.

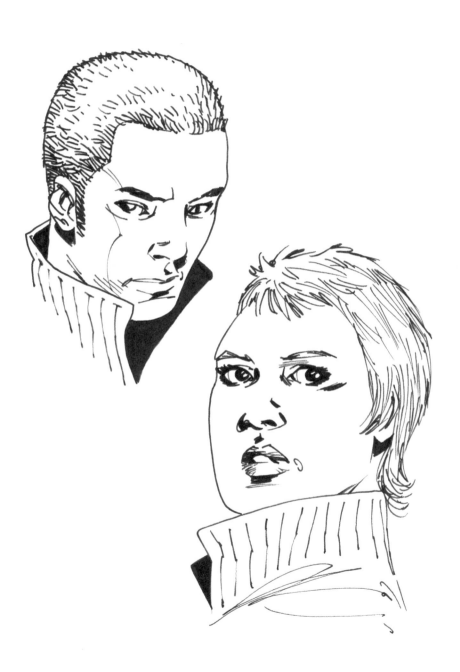

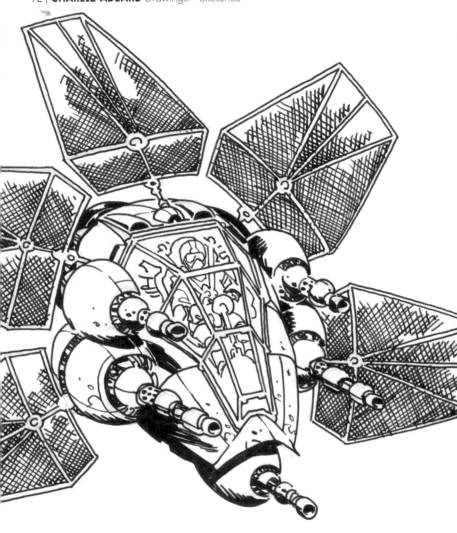

"This is a short-range pirate
fighter. The story starts when
the tanker is attacked by
space pirates, and things go
down hill from there. When
designing spaceships it's just
about how they look and I
love solar panels!"

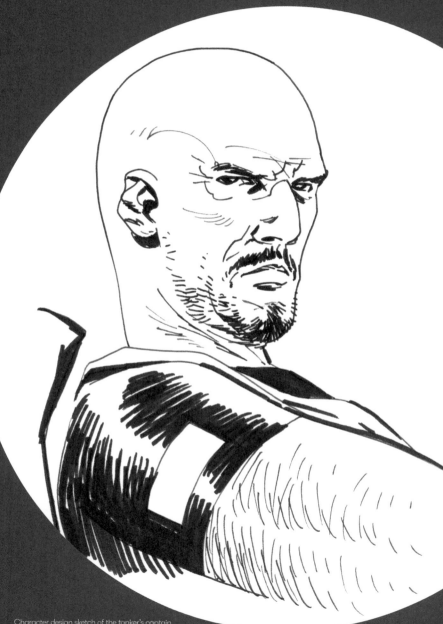

Character design sketch of the tanker's captain.

The Passenger Spaceship

"The schematics below were drawn by me for a friend who had Google Sketchup and he was going to create a 3D model of the spaceship based on them, so I could rotate it in any position print off a blueline and draw that angle. I would never had draw these for myself. The idea was that the ship is supposed to be a space tanker. With space things don't need to be aerodynamic, so I was looking for a completely utilitarian design, there's no reason for aesthics in space! The tanks are just tanks, they don't have to be shaped to flow through air or water. The top of the ship was partly inspired by an aircraft carrier's bridge."

"The earlier design, on the opposite page, had solar panels, which I removed, as the look wasn't right. In the **Passenger** universe everything is in Chinese, hence the graffiti on the tanks."

Below: Technical plan drawing, ink.

Right top: Side view of ship, ink.

Right bottom: Initial concept sketch, ink.

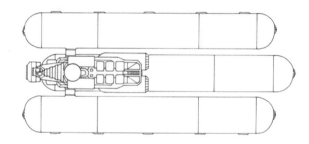

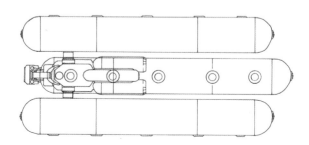

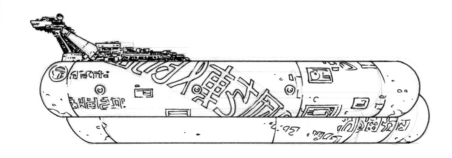

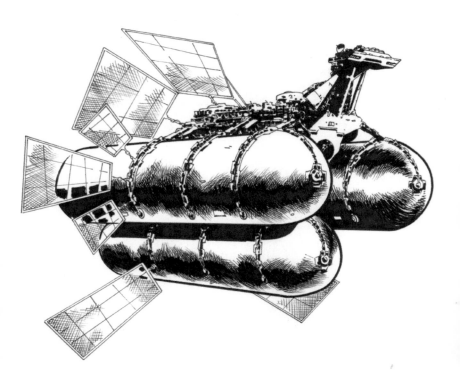

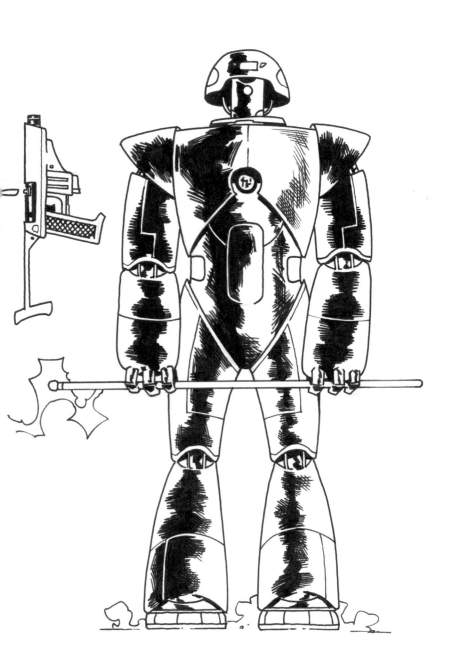

"I've never been a particulalry big thumbnailer, or into doing loads of designs. I think it's partly me being a bit lazy, and partly wanting to get into the 'meat and taters' of the work i.e. drawing the actual comic. I'm not patient enough to spend days designing stuff."

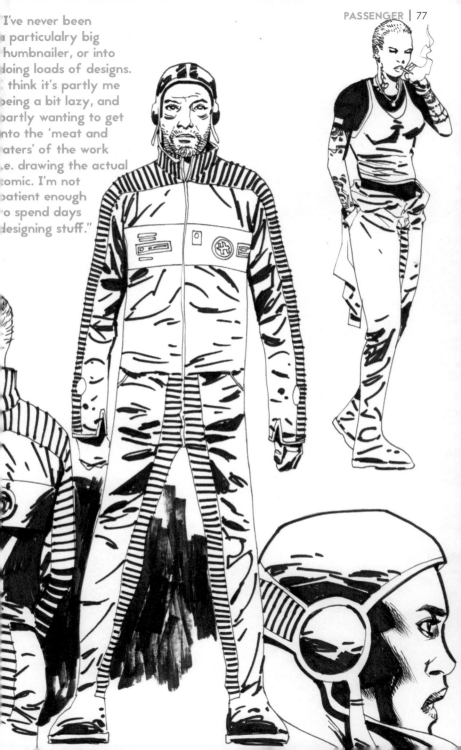

Charlie Adlard has played the drums in his band, The Cosmic Rays, since it formed in 2009 at the ICE Comic Expo in Birmingham.

"I'm the only original member of the band left! Initially we were a covers band called Giant-Sized Band Thing with fellow comic book artists Phil Winslade and Liam Sharp, and comic journalist Paul H Birch. Then we called ourselves Mind Power Cosmic, but we abandoned that for Cosmic Rays because it was easier to say and remember!

The music is constantly evolving, from Prog Rock to Alternative Rock, and in our latest incarnation we're even veering more towards Cosmic Pop! The current line-up includes Tim Cooke on guitar, Adam Knight on bass, James Yule on guitar and keyboard, and comic convention organiser Shane Chebsey on vocals."

They've produced two albums, the self-titled *Cosmic Rays*, and *Hard to Destroy*. This painting is the cover of their *Trust the Process* EP.

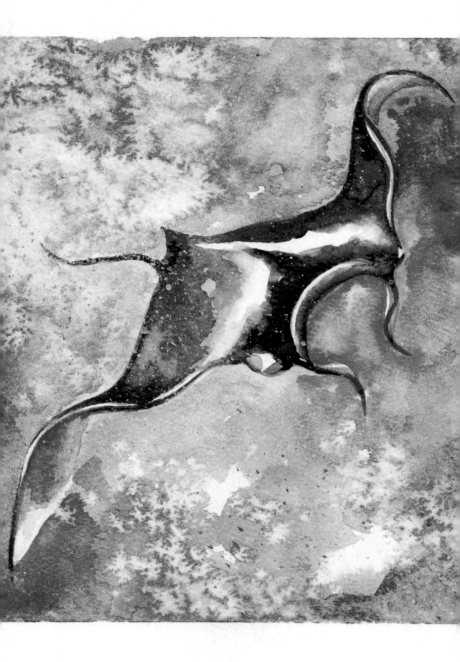

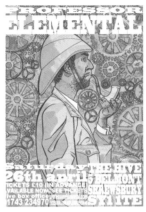

Above:

Professor Elemental

"The Cosmic Rays played with him at The Hive, our local arts centre. He's a great performer." This was the cover of Chap-Hop artist Professor Elemental's Comic #4.

Above:

Final art for the Hive gig poster, using same elements of the comic cover.

Below left: Finished album art for **These Machines are Winning** with colours by Charlie.

Below right: Heads of state inks over blueline.

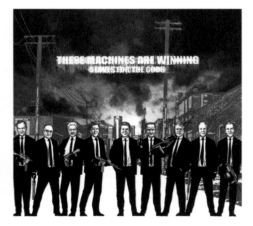

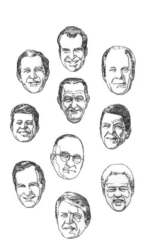

Slaves for Gods
These Machines Are Winning

"Dylan Silvers, an ex-member of Polyphonic Spree, was developing a musical multimedia experience. He actually got [fellow **2000 AD** artist] Jock involved. There was a comic strip where these guys had presidential masks on *a la* **Point Break**. I Google image searched the Presidents' faces, bluelined and inked over those and removed the eyes. I like it with the blue as it acts as a gradient. Although

I composited it on computer I didn't draw this on a Cinteq. I scanned these in and then stuck them on the bodies and then put them in the background. It was square for an LP, but he did ask for a comic shaped version as well, which I extended at the bottom and put shadows, so there wasn't just negative space at the bottom. I worked quite a long time on that. This is actually my favourite album cover that I've done so far."

Above: Cosmic Rays Interior gatefold album art, ink on
blueline. "This was the only thing for the album I actually
drew. Everything else was either digitally painted or
composed."

Opposite page: District of Broken Hope gatefold cover art
for Canadian rock band Ravenscode. Finished inks over
blueline. "I'm working on their second album cover at the
moment."

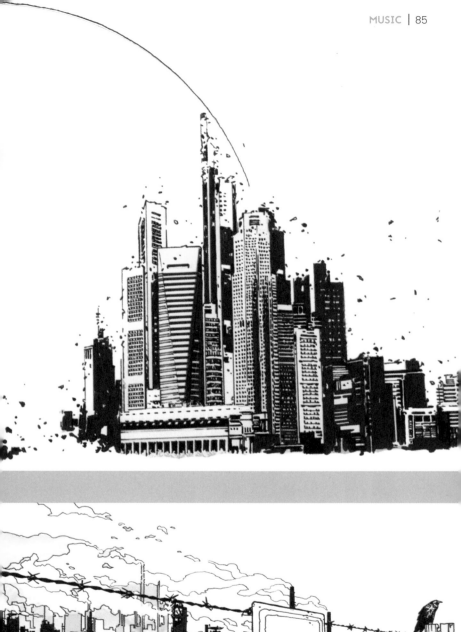

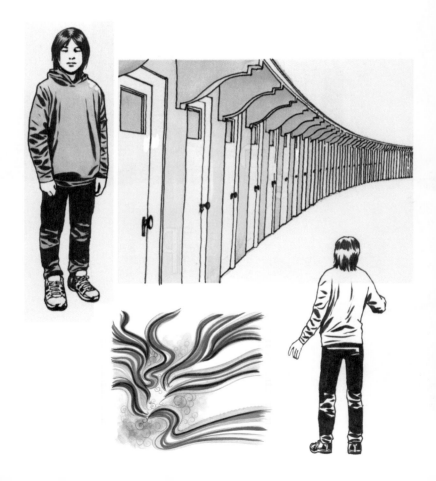

This page and opposite:
The Spirit of Christmas single by Fynnjan (2013)
"This was the cover to a charity single by a
friend-of-friend's son. He was an 11 year-old with
Asperger's who wrote the song himself."

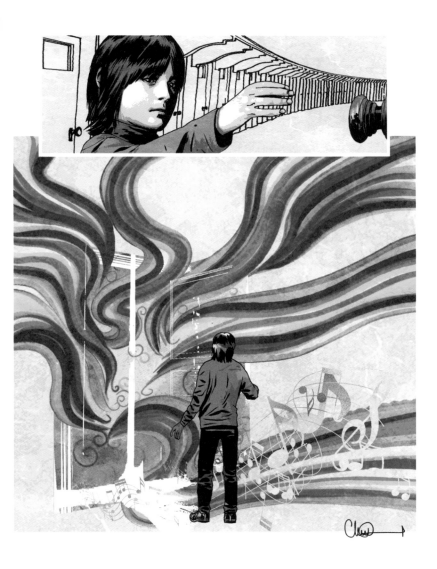

Below: Finished inks and digital colours
My local musical instruments shop in Shrewsbury, Music
Bros., asked me to do some designs for them.

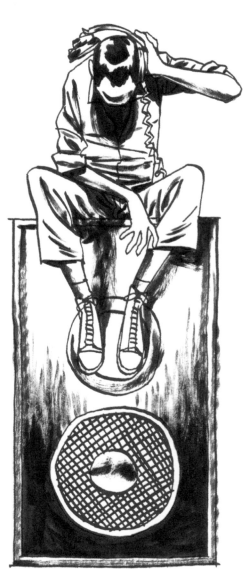

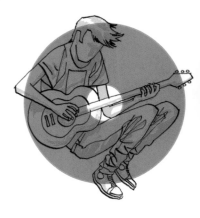

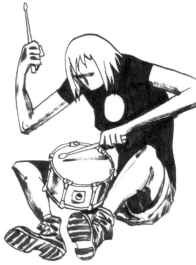

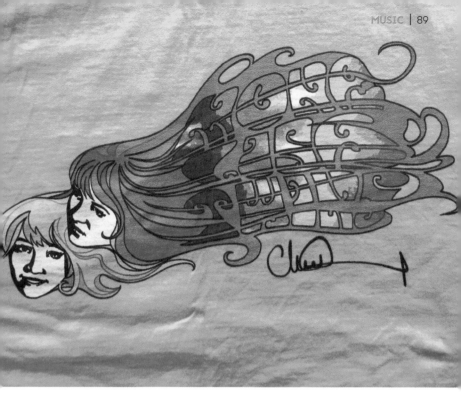

Above: Final colour print logo.

Below: Finished inks with blueline.

Mona Lisa Twins

"I generally say yes to job proposals related to music. Tim Quinn was managing them (they're Austrian, I think). They're a Beatles-esque Sixties sounding band based in Liverpool and this was a T-Shirt design for them." The design was flipped for the final print above.

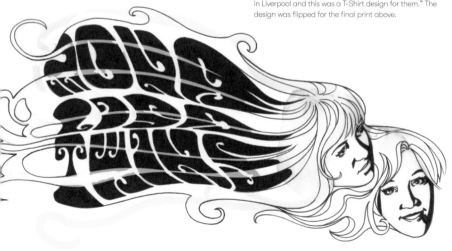

MISCELLANEOUS

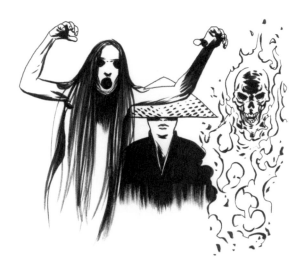

Above and opposite page: **The 12**, Brush and ink on tracing paper.
"In my wilderness years, between **The X-Files** and **The Walking Dead**, I drew loads of different things and this was a proposal by writer, Andi Ewington. The final artwork had the tattoo coloured in purple and the figures above were digitally composited into the background."

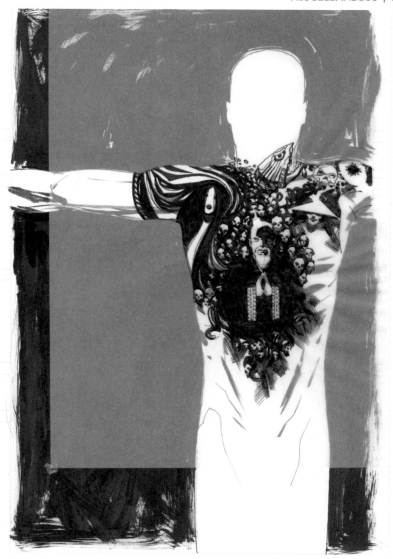

Following pages:
IDW's adaptation of **Hell House** by Richard Matheson. "I left that project early on because Robert asked me to do **The Walking Dead**. I knew whatever I was going to do for IDW, at the time, wasn't going to be seen that much. It was a pretty straight adaptation, but I never saw a full script for it."

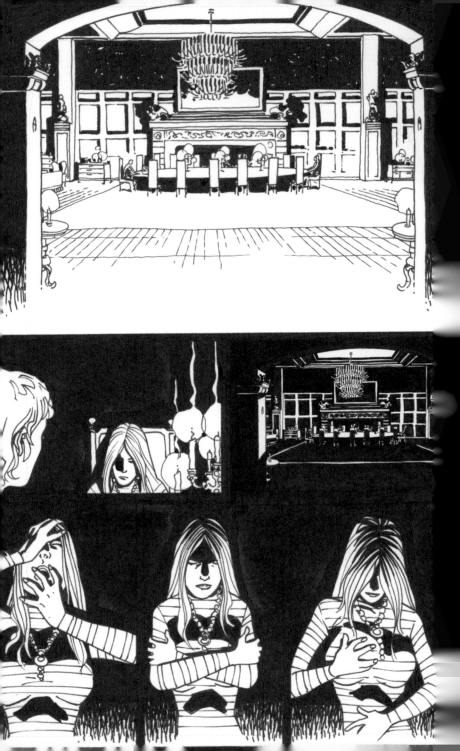

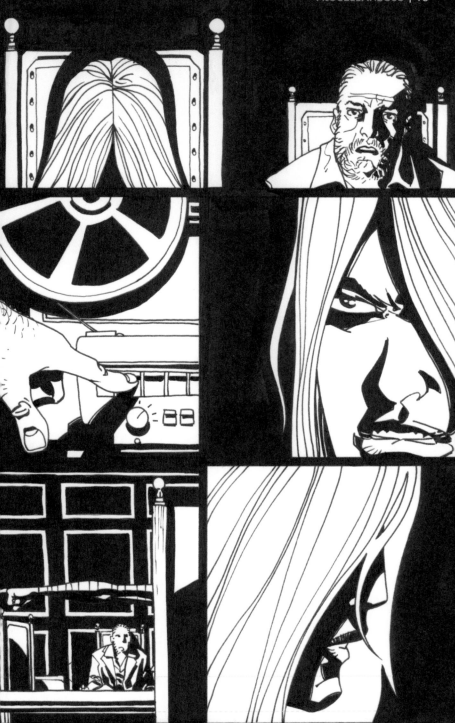

Left and Below: Pen sketches.

"Talking with Joe Casey years ago, around the late Nineties, before we did **Rock Bottom**, I had the idea of doing a widescreen comic, so three tiers of panels, like Panavision. I was looking at the contempory wild west. So I was just trying out concepts, but it never went further than these sketches. It's be really cool shaped book."

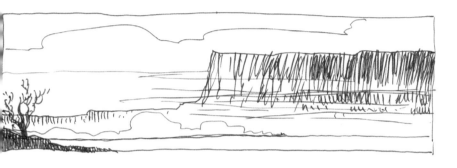

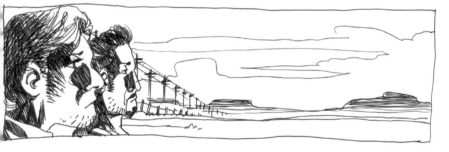

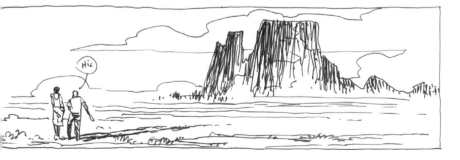

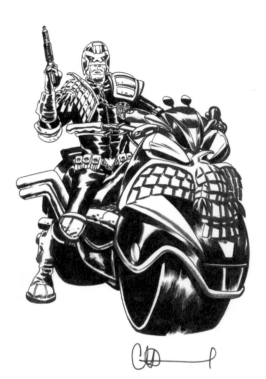

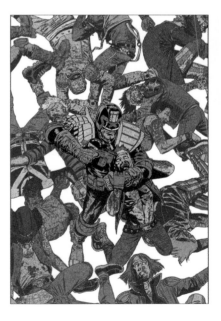

Right: **Best of 2000 AD #3** cover (Rebellion, 2020)
(Digital inks and colours).
Opposite page: Finsihed pencils.

"I recently did a variant for the new **Hellblazer** comic. I got
a mysterious message from a guy at Rebellion [2000 AD's
publisher] requesting a Judge Dredd cover for something,
which turned out to be this! It was good fun drawing Dredd
again. I hadn't drawn him in ages. The brief was "We want
to see Dredd in mid-action doing something,' which filled
me with a bit of trepidation, because I don't like big action
covers, as that's like any Marvel or DC title over the last few
decades. I prefer more designer covers that catch your eye
from afar. Dredd's just beaten up a bunch of juves and has
one in a headlock."

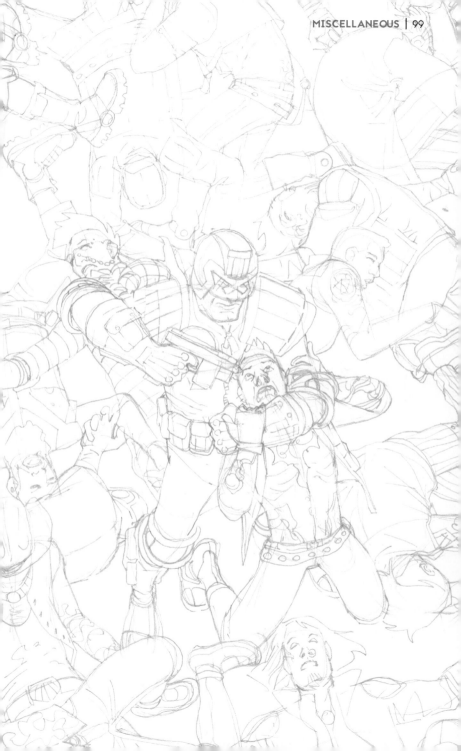

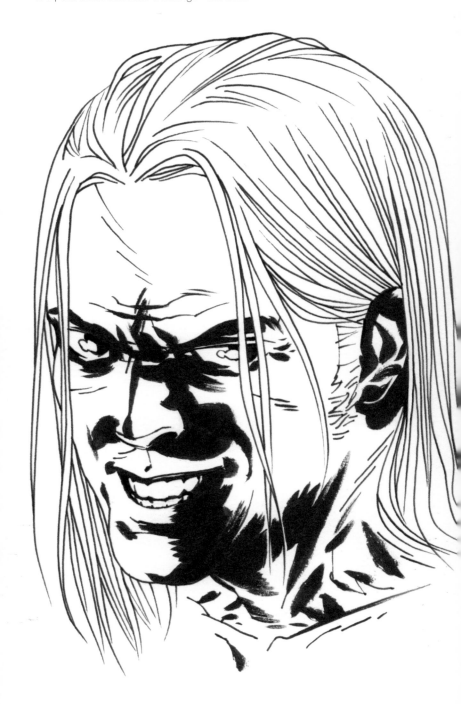

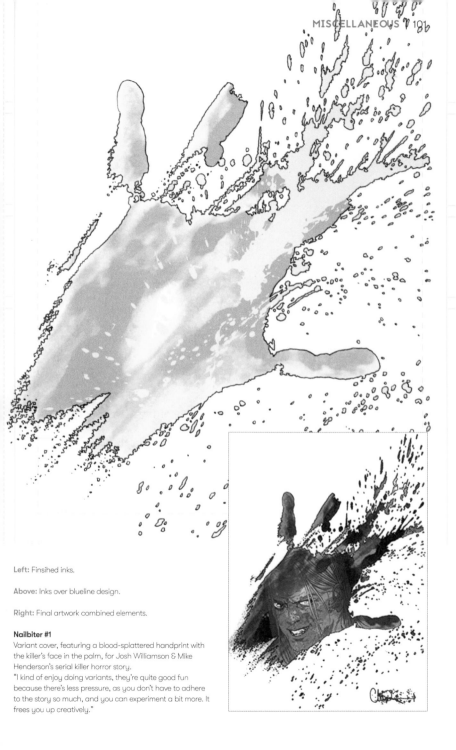

Left: Finsihed inks.

Above: Inks over blueline design.

Right: Final artwork combined elements.

Nailbiter #1
Variant cover, featuring a blood-splattered handprint with the killer's face in the palm, for Josh Williamson & Mike Henderson's serial killer horror story.
"I kind of enjoy doing variants, they're quite good fun because there's less pressure, as you don't have to adhere to the story so much, and you can experiment a bit more. It frees you up creatively."

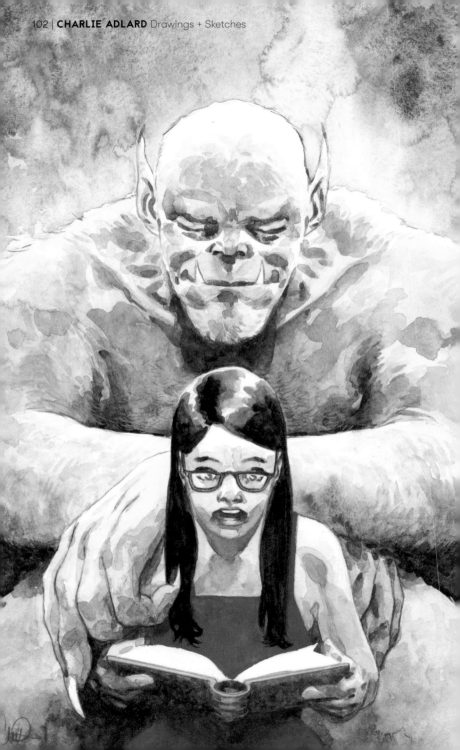

Above: **Love Seat**, inks with digital blueline.

"This was promotional art for a guy I met in Strasbourg at a convention a few years back. He moved to the States and produced his first short film about a guy who falls in love with a bit of furniture. The art was then digitally composed."

Left: Girl and Golem (watercolours and pencil).

"This went up in the window of Waterstone's bookshop in Kendal, as part of the Lakes International Comic Arts Festival 2019's Walking Trail. The theme was 'Monsters' but I didn't want to do the obvious nasty monster. I thought it was nice to have a friendly monster. They were talking about using a **Walking Dead** piece initially that I already had. The best bits of artwork are when the idea hits you straight away. I woke up and suddenly decided I'm going to do this in watercolour, that'll look nice! I was quite pleased with this."

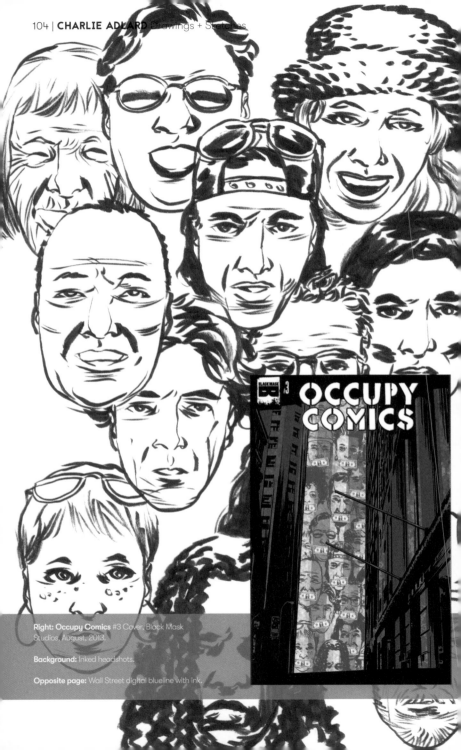

Right: Occupy Comics #3 Cover, Black Mask
Studios, August, 2013.

Background: Inked headshots.

Opposite page: Wall Street digital blueline with ink.

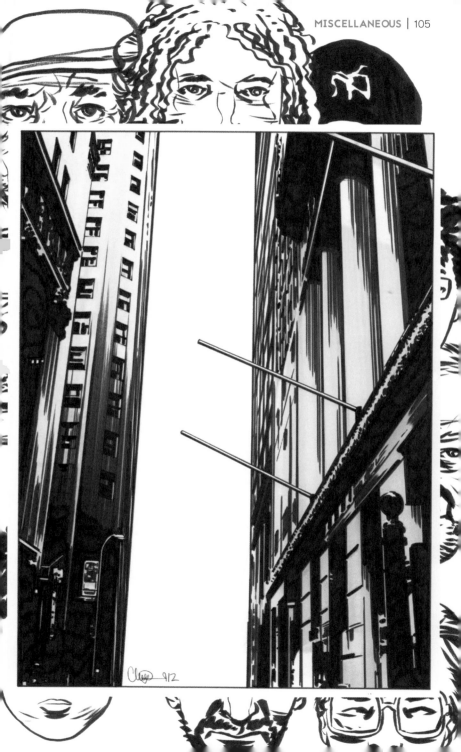

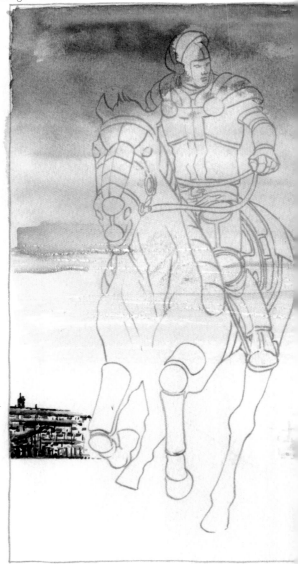

Below: Pencil drawing.

Right: Watercolours on pencil.

Next page: Finished inks.

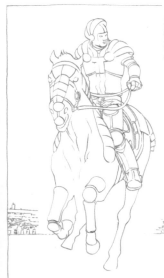

"This is the only piece in my entire career when the publisher, Kymera, said 'just do a poster' So I said, 'Of what?' and he said 'it doesn't matter!' So I had no brief at all! God knows why I chose a man on a horse, in armour. If someone asked me to do that now I'd probably decline.

In my mind I think it was an alien world. But it's nice to do one-off images as you can spend more time on it and concentrate on elements you wouldn't normally have time for in a comic, like composition and design, whereas in comics it's 'just get it done!' The danger is you could spend forever noodling around on something never reaching a decision. Especially with digital work.

This was a complete experiment. I didn't want to ruin the original drawing so I photocopied the line art onto watercolour paper, painted it and evidently wasn't that happy with it because I completely changed the background colour. I eventually composited the whole thing and it was one of my first pieces of artwork using Photoshop."

"It's nice to do one-off images as you can spend more time on it and concentrate on elements you wouldn't normally have time for in a comic."

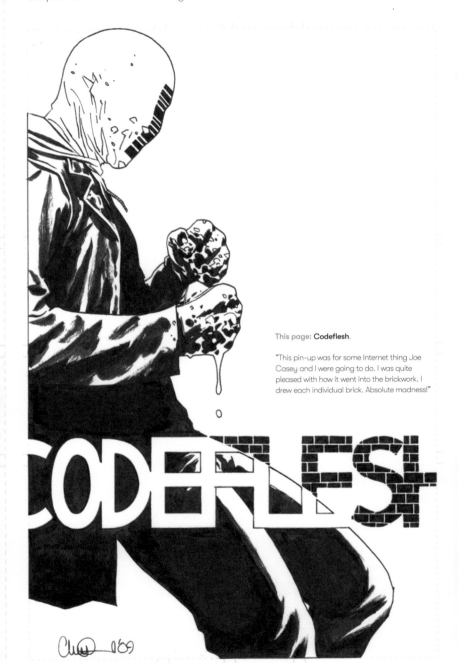

This page: **Codeflesh**.

"This pin-up was for some Internet thing Joe Casey and I were going to do. I was quite pleased with how it went into the brickwork. I drew each individual brick. Absolute madness!"

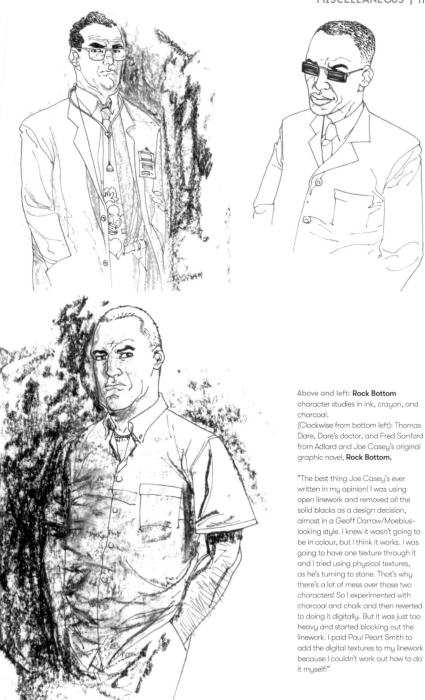

Above and left: Rock Bottom character studies in ink, crayon, and charcoal.
(Clockwise from bottom left): Thomas Dare, Dare's doctor, and Fred Sanford from Adlard and Joe Casey's original graphic novel, **Rock Bottom.**

"The best thing Joe Casey's ever written in my opinion! I was using open linework and removed all the solid blacks as a design decision, almost in a Geoff Darrow/Moebius-looking style. I knew it wasn't going to be in colour, but I think it works. I was going to have one texture through it and I tried using physical textures, as he's turning to stone. That's why there's a lot of mess over those two characters! So I experimented with charcoal and chalk and then reverted to doing it digitally. But it was just too heavy and started blocking out the linework. I paid Paul Peart Smith to add the digital textures to my linework because I couldn't work out how to do it myself!"

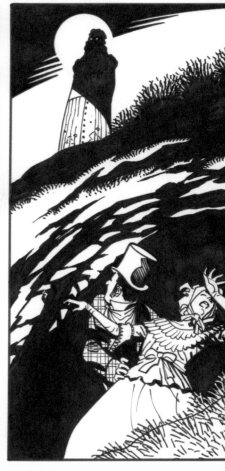

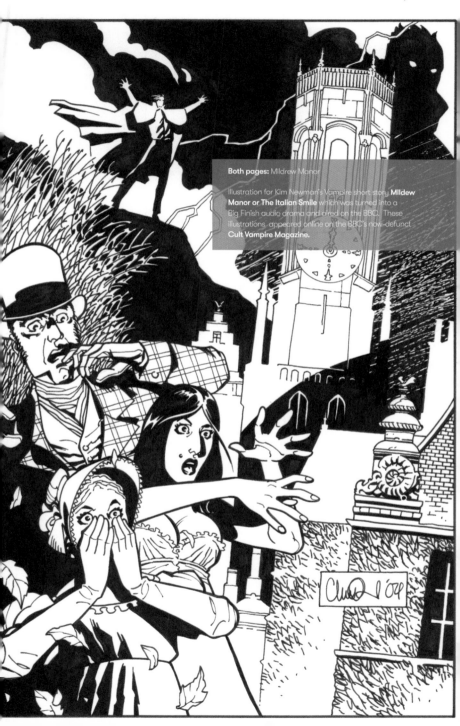

Both pages: Mildrew Manor

Illustration for Kim Newman's Vampire short story **Mildew Manor or The Italian Smile** which was turned into a Big Finish audio drama and aired on the BBC. These illustrations appeared online on the BBC's now-defunct **Cult Vampire Magazine**.

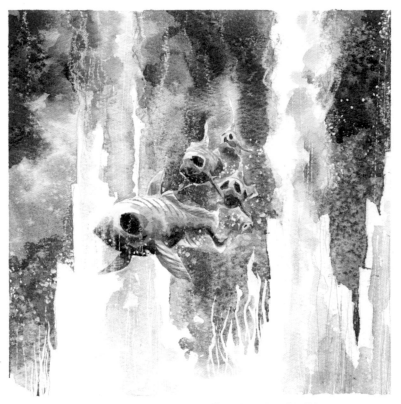

Above: Watercolours, Fish, 2019.

"Greenpeace approached me and Quentin Blake to do some artwork for an online campaign raising awareness about deep sea vents. As oil companies are sending these massive machines to drill on the oceon floor. The reason it is square is so it fitted into Instagram easily."

Opposite page: Harley Quinn #38 (2003, DC Comics) Written by A.J. Lieberman Unpublished pencils.

"I tend to bear in mind that the equipment I'm using dictates the way I draw. I was doing a lot of black outlines... This scene didn't appear in the comic. I inked this page, but I can't remember why this wasn't unused."

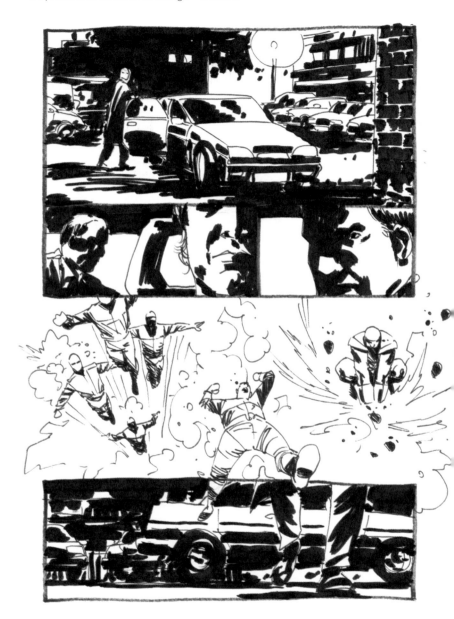

Above: Ink layout sketch.

Right: Finished inks on blueline.

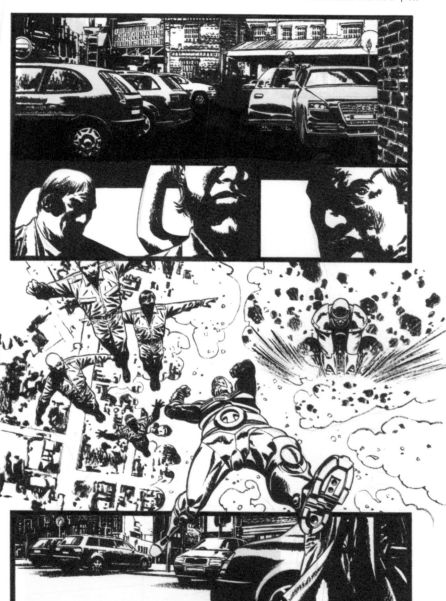

Single page of Andi Ewington's **45 (Forty-Five)** Com-X, 2010. "That's the car park at Shrewsbury train station! This was one of the very rare times I actually went out and took some reference photos and came back and drew it, rather than using Google image search."

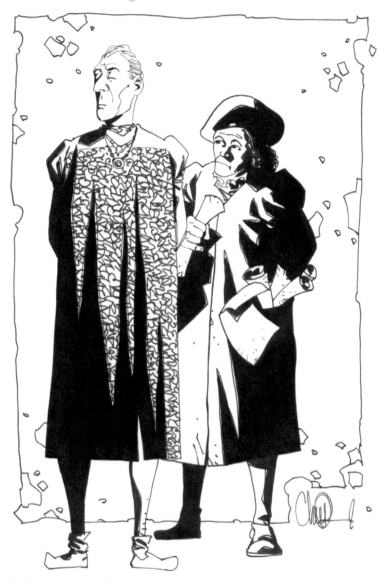

Above: **Heretic** original character sketches.

"I've done loads of comic book proposals with Robbie Morrison and this one was originally drawn over 20 years ago! Heretic is set in 1529 and features Heinrich Cornelius Agrippa (left) who was a teacher of Johann Weyer (left). Agrippa was also one of the first people to challenge a 'witch trial and got the witch' off. He was a scientist/ knight who believed in logic and rationality, rather than supernatural. It's **The Name of the Rose** meets Sherlock Holmes."

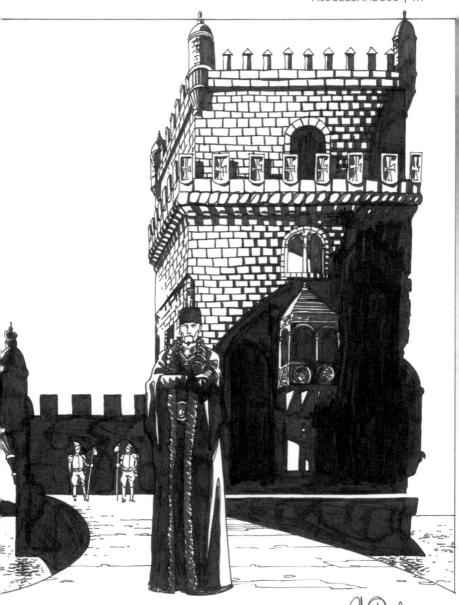

Above: **Heretic** promotional art.

"Because it's set in the real world I needed to find pictures of buildings that already existed. I was in Lisbon last year and came across this castle that I'd drawn 19 years previously! So, this won't be appearing in the final book, as the story's not set in Lisbon! It's the first book I've worked on completely digitally, both pencils and inks."

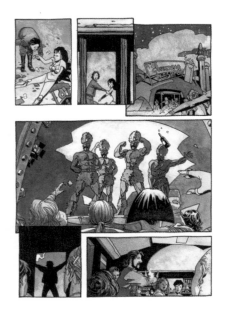

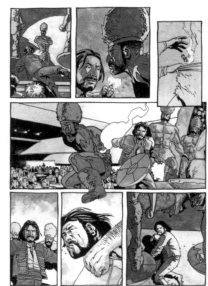

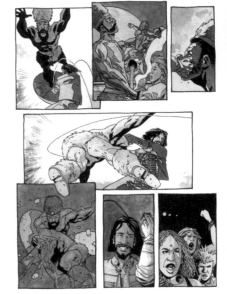

Above, right and opposite: Nikolai Dante, watercolours on inks. (1997, **2000 AD**).

"This is one of the few times I've done colour for **2000 AD**. I printed the inks on to watercolour paper at A5 size, via my local printshop. Then I painted on top."

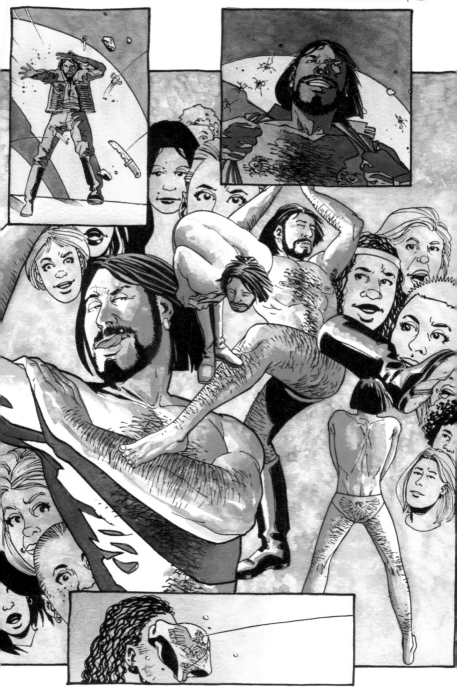

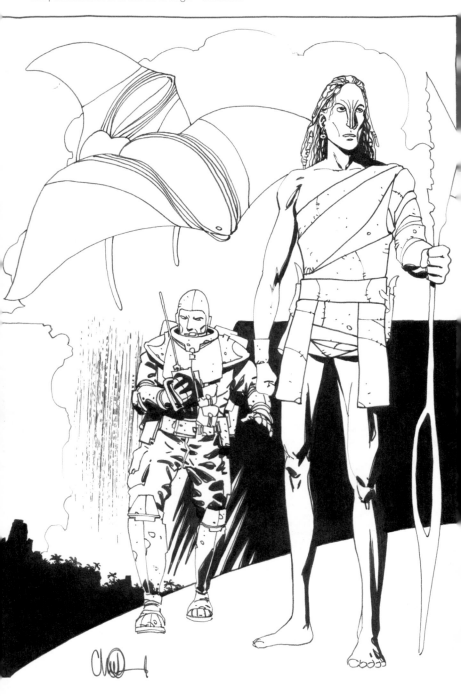

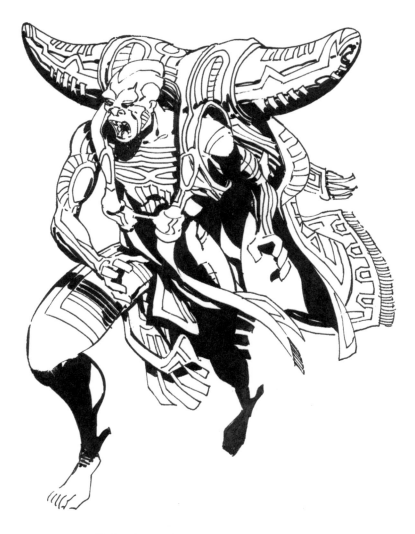

This Page: Dances with Demons character sketch (writer Simon Jowett, 1993).
This was based on Edmund Perryman's original design for the 4-issue miniseries in Marvel UK's Frontier imprint.

Opposite Page: Concept art for a comics proposal.
"Knowing when a piece is finished tends to be a time thing, but you never really do, to be honest. I can literally spend ages staring at a piece of work going 'Is it finished? I don't know. Is it? Is it? Is that the best I can do? [pause] Probably.' [Laughs] Or it's 'I've spent two days on this, that's more than enough.' I did a **Hellblazer** cover recently and I got into that spiral of just constantly tweaking and you can drive yourself mad."

Studio Life

"My style is fairly constant, but it all comes down to equipment. In **Passenger**, for instance, I wanted to use more brushes and it dictated that kind of mark making. Whereas **The Walking Dead** was more pen and ink, so that dictated another type of mark-making. Creating digitally dictates another way...so **Rock Bottom** looks very different to **White Death**, but I'd argue the style underneath is very similar. It looks radically different because the types of marks made with chalk are very different to those made with a thin pen. I'm not Mike Mignola, in the sense that everything he does is in the same style and using the same techniques and tools. He's a genius, but that's the way he works. I always want my work to look like my stuff, but each project looks different because of different equipment. I think if I always used the same tools I'd get bored. What kept me going on **The Walking Dead** was that I had opportunities to do side projects, which broke up the 15-year run of relentlessly drawing one strip. I think I would've gone insane! A change is as good as a rest!"

"My style is fairly constant, but it all comes down to equipment."

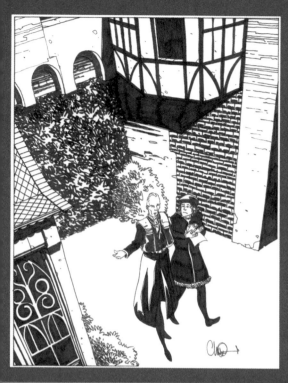

Left: Early **Heretic** sample page.

"If I'm doing layouts or sketches now I tend to do them on my iPad or Cintiq because it's just quicker and easier and saves wasting paper. I save the scanning stage"

"The advantage of working digitally is you cut out that first developmental stage even more, just by the psychological fact that you can easily rub out stuff and start again, whereas if you were drawing it physically it's much harder to white-out and re-ink over, which is never an easy process. So digital gets me to that process stage a lot quicker than physical.

When working digitally I still work on a traditional page layout. I still like to see the whole page on the screen. I tend to pencil on one layer and ink on another layer and that's it. It's all very traditional. The interesting thing is that most artists that work digitally are keen to make the art look as physical as possible. Why?! If you're going to do that you might as well sit at a drawing board! So embrace the technology and embrace the fact that you can make your brushes look more than just like a brush pen! I'm far off doing that myself, but I'm getting to the point where people will be able to spot 'Oh he's obviously doing that digitally!' Yeah! It's not a secret! The reason I embrace technology is that it's a different way of working. It's not faster, but it makes certain things easier, and in other ways it makes decision-making harder, because there's too many choices! But it's nothing to do with speed. It's just a different way of working that makes life exciting!

I download thousands of brushes, but I tend to use the same ones. For each project I like to stick to my limited tools, just because it binds the artwork together more. If you're using 20-30 brushes or tools it starts to looks schizophrenic and there's no style—just a mash of shapes. With **Heretic** (written by Robbie Morrison) I'm actually using pencil tools to ink, because I want a rougher feel to the artwork. It's set in the 16th century, so I want that old, charcoal-esque feel to the art, as I think that will fit the story, rather than clean brushstrokes. So I'm using a 6B pencil tool that gives a nice rough line and I'm using a chalk tool for a bit of greytone."